digital
flower
photography

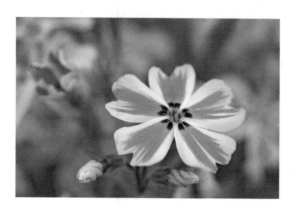

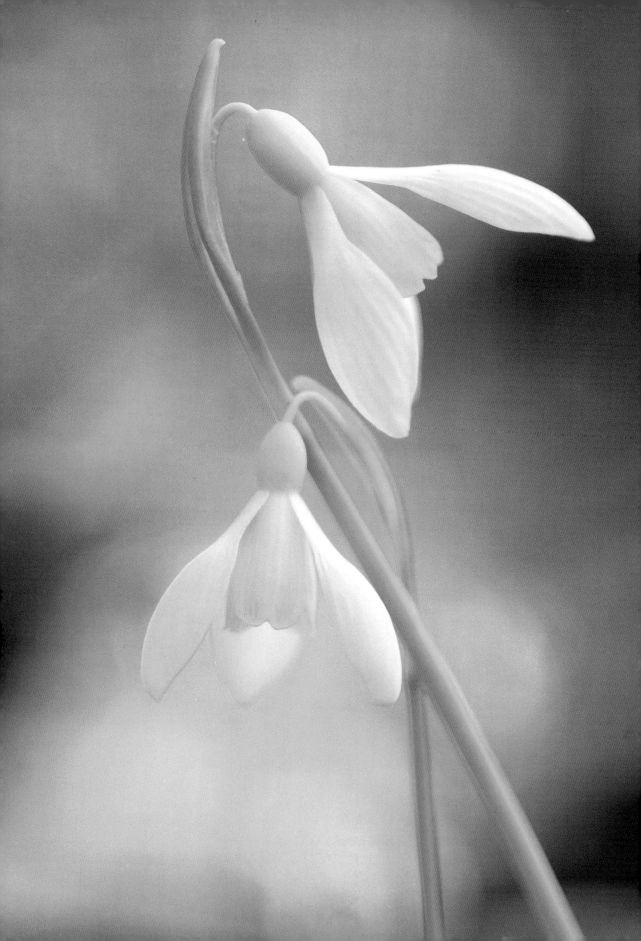

digital flower photography

SUE BISHOP

photographers'
pip
institute press

First published 2008 by
Photographers' Institute Press
An imprint of
Guild of Master Craftsman Publications Ltd
Castle Place, 166 High Street,
Lewes, East Sussex BN7 1XU

ISBN 978-1-86108-516-0

The publishers and author can accept no legal responsibility for any consequences
arising from the application of information, advice or instructions given in this
publication.

A catalogue record for this book is available from the British Library.

Associate Publisher: Jonathan Bailey
Production Manager: Jim Bulley
Managing Editor: Gerrie Purcell
Editor: Mark Bentley
Managing Art Editor: Gilda Pacitti
Designer: Terry Jeavons

All photographs by Sue Bishop, except those on pages 13, 15, 16 and 34. Thanks to
Canon, Fujifilm and Nikon for use of their images. Thank you also to RHS Garden Wisley
for permission to photograph the cherry trees on pages 36 and 41.

Set in Linotype Tetria Tab

Colour origination by GMC Reprographics
Printed and bound in Indonesia by Sino Publishing

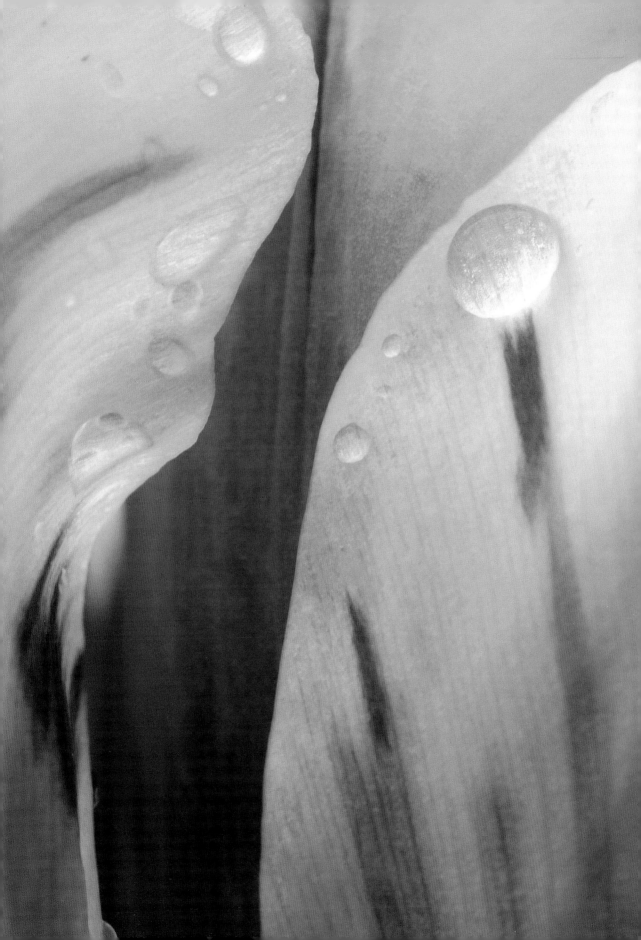

Contents

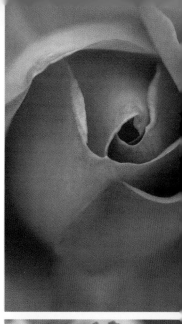

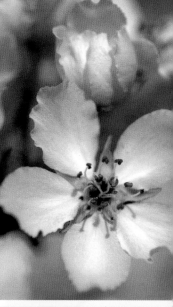

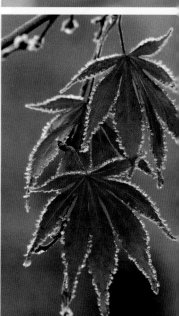

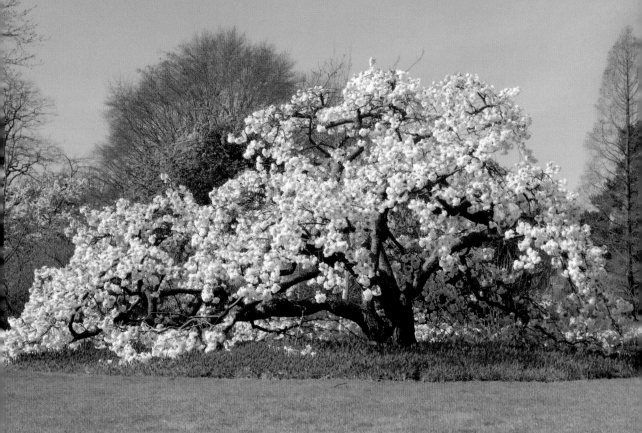

Introduction

Throughout the centuries people have endeavoured to represent flowers in paintings, ceramics, embroidery and many other visual media, and once photography was born photographers joined the quest for that elusive perfect depiction of a flower. The digital age has brought with it yet more possible ways to capture a picture, from the most sophisticated DSLR to the ubiquitous mobile phone. But although the technology has become more and more accessible to everyone, has it also really become easier to make a wonderful image of a flower?

It seems a contradiction in terms, but I sometimes think that because flowers are such beautiful things, with their delicate petals, intricate shapes and graceful curves, not to mention sumptuous colours of every conceivable hue, it is actually quite difficult to make a really outstanding photograph of a flower. It's comparatively easy with the technology available to us to make an acceptably good image of a flower, one where everything is properly exposed and properly sharp, and the resulting picture will look good in as much as the flower itself looks good. I suppose the difficulty lies in making a photograph that doesn't merely rely on recording the beauty of its subject for its effect, but in some way enhances the subject to make an image that is more than just a record of a lovely thing.

To make a stunning photograph of any subject, you first need to be completely familiar with your equipment and how to achieve the technical effects you want. In addition to this, you need to fine-tune the way you see, and develop an awareness of light, colour and composition. Then, when you are in a lovely garden or a meadow of wildflowers, all this knowledge can come together almost in your subconscious, leaving you free to devote all your attention to responding to what you see and creating a photograph that will really do justice to your subject. To photograph a flower is to look through your viewfinder and lose yourself in a world of colour, light and shape – and to produce an image that reflects the beauty that you see.

TULIP
Nikon D1x with 105mm lens, ISO 125,
1/1250sec at f/3.5

1 Cameras

Making choices

The range and diversity of photographic equipment now available are greater than at any time in the past, with people making images on anything from a mobile phone to a large format film camera. Digital camera technology has come on in leaps and bounds in recent years, and to read some of the advertisements for these cameras one would almost think that the technology is so advanced that the cameras will make all the photographic decisions themselves and take one masterpiece after another with hardly any input from the photographer. But of course, no matter how expensive a camera is, it is still a tool which can do nothing without a photographer to use it and understand how it works. It can be daunting for a photographer wanting to buy digital camera gear to know where to begin, but when choosing a camera, the important thing is to identify the features that matter to you as a photographer and then to choose a model which best suits your aims and requirements. This chapter will look briefly at the different types of digital equipment which are available.

If you are interested in close-up photography, look for a camera with relevant features such as a depth of field preview button.
Nikon D2x, 105mm macro lens, ISO 100, 1/2sec at f/22

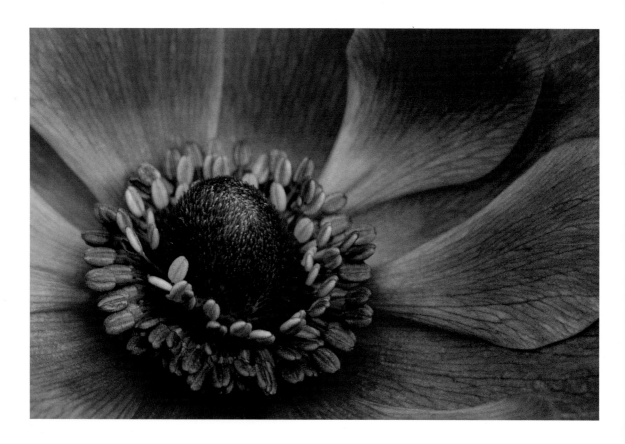

There are many excellent compact cameras on the market.

In the shade

Some compact cameras do not have a viewfinder, and it can be hard to see detail in the LCD monitor in bright sunlight. There are various makes of inexpensive universal pop-up shade available, such as the Delkin Digital Stick on Shade, which attach to the camera with a non-residue adhesive, and cast shade onto the monitor so that the picture is clearer and brighter.

Compacts

There is an enormous range of digital compact cameras now available and many of them are capable of producing high quality results. Their biggest advantage is that they are so small and lightweight, and of course comparatively inexpensive. Many compact cameras offer a macro or close-up mode, and this is definitely something to look for if you are intending to use one for flower photography. A good optical zoom is also a plus – and this is much more important than the digital zoom, which enlarges the image at the expense of causing deterioration. When choosing a model, do be aware that not all compact cameras have a viewfinder – on some models the subject can only be viewed through the LCD monitor. This can be a drawback in bright lighting conditions when it's harder to see detail in the monitor. There is a large range of megapixel resolutions on offer, and generally the higher the megapixel number, the larger the print which can be made from the image file. As a guide, four megapixels is the minimum resolution for printing up to A4 or letter size.

Compact cameras

Advantages
- Lightweight
- Small enough to slip into your pocket
- Comparatively inexpensive

Disadvantages
- Less opportunity to override automatic camera settings
- Cannot use interchangeable lenses
- Some models do not have a viewfinder

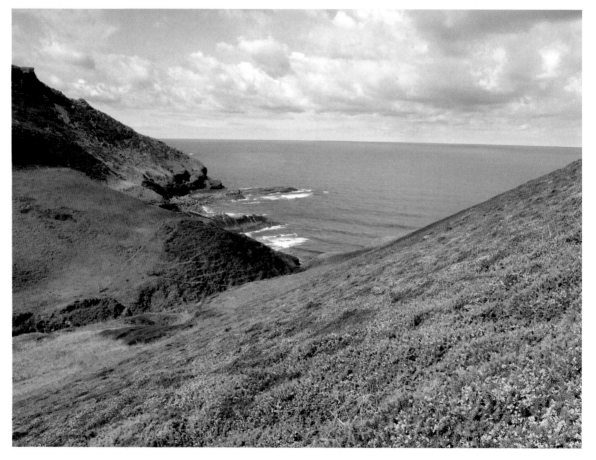

CORNWALL COAST WITH FLOWERS

For the picture above, I set out on a hot August day to walk part of the Cornish coastal path, which goes steeply up and down from cliff top to beach level at regular intervals. I didn't feel inclined to carry my usual heavy bag of gear and tripod – but a compact camera weighed almost nothing and enabled me to photograph the lovely coastal flowers against the backdrop of the sea.

Panasonic Lumix DMC-LX2, ISO 100, 1/400sec at f/5.6

Digital and optical zoom

Most cameras offer both digital and optical zoom, and it is important
to understand the difference. Optical zoom works just like a zoom
lens on a DSLR – the lens physically changes its focal length and
therefore the image magnification as it is zoomed. Digital zoom, on
the other hand, simply takes a crop from part of the existing image
and enlarges it, which causes a loss of image quality. All digital
images are made up of tiny squares or pixels, and the more the image
is enlarged, the more evident the pixels become. The two photos
opposite show the effect of digital zoom taken to an extreme.

SLR-style digital compact cameras

Advantages
- Usually lighter than a DSLR
- Offer more options for
 overriding automatic settings
 than a compact

Disadvantages
- Cannot use interchangeable
 lenses
- Bulkier than a compact

SLR-style compacts

In size and specification these cameras fall between compact cameras
and digital SLR cameras, and can be a good compromise for a
photographer wanting more photographic control than a compact
will give, without the expense and weight of a DSLR. Like compacts,
they have a fixed zoom lens rather than interchangeable lenses,
but they usually offer a better range of options for the photographer
to override automatic aperture and shutter speed settings and thus
have more creative control. In addition, many can shoot Raw files
as well as Jpegs, which gives the photographer more flexibility for
working on the image later on a computer (see page 19).

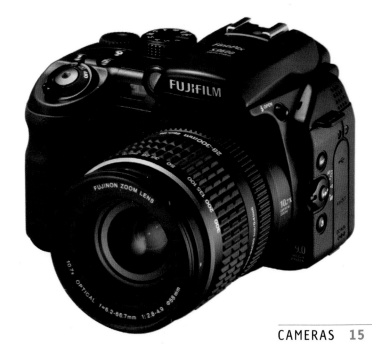

SLR-style digital compacts often have
a good close-up focusing ability, which
is important for flower photography.

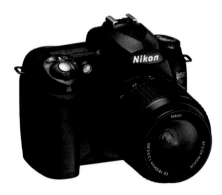

DSLRs will usually offer a range of Jpeg file sizes, as well as the option to shoot Raw files.

Digital SLRs

Advantages
- A full range of lenses can be used
- The photographer has full control over all camera settings
- Usually offer a wider range of exposure and focus modes than other cameras

Disadvantages
- Heavier
- Bulkier
- More expensive

Digital SLRs

Like film SLR cameras, DSLRs have interchangeable lenses, and this, of course, gives a much greater range of lens length than is available with any fixed lens camera, allowing a wider spectrum of creative possibilities. For a flower photographer, it means that a true macro lens can be used, allowing even closer focusing together with optimum quality. If you are changing from a film SLR to a DSLR, it may well be that your existing lenses will be useable on the DSLR body – but it's wise to check with the manufacturer as occasionally some metering or focusing functions can be lost when using much older lenses.

The disadvantages of a DSLR as compared to a compact camera are the size and weight, and the higher price – but these bring with them greater versatility and in general a higher quality image. There will also usually be a wider range of exposure modes and focus modes to choose from, and in particular the option to use manual focus, which many compact cameras do not offer. Although auto focus is wonderful for many photographic situations, for close-up photography the choice of point of focus can be very crucial because of depth of field considerations (see page 59), and so manual focus is usually the better option.

POACHED EGG FLOWERS

I photographed these tiny poached egg flowers at a wide aperture so that only one flower would be sharp with the rest thrown out of focus. This meant I had to be very accurate in choosing the point of focus, and in such a situation manual focus often allows more precise control than auto focus.
Nikon D1x with 105mm macro lens, ISO 125, 1/1250sec at f/3.3

CYCLAMEN

The range of lenses available with a DSLR allows a great deal more flexibility than a compact camera does. I used a 105mm macro lens for this shot of tiny cyclamen flowers. Even though a compact camera may have been able to focus this close, the lens would have been much wider, which would have made it more difficult to achieve a pleasing background behind the flowers.

Nikon D1x with 105mm macro lens, ISO 125, 1/500sec at f/3.5

File types

A digital camera can save images as various different types of file, and the type you choose will depend on the way in which you want to use your photographs.

Jpegs

Jpegs (developed by the Joint Photo Experts Group) are the smallest of the various file types. Because they take the image data and compress it, they take up less space on the camera's memory card. Even within the Jpeg category, there is usually a choice of Jpeg sizes from fine through normal to basic, with basic taking the least memory space of all. However, the saving of space on the memory card comes at the expense of loss of image quality – the more a file is compressed, the more information is lost.

SAVING AS FILE TYPE

Photoshop will offer you a drop-down menu with options for the file format when you want to save your photograph. If you are shooting Raw files, it's best to save them as a PSD or a Tiff in order not to lose any of the information.

A basic or normal Jpeg file will be sufficient for producing a small print or for viewing on a computer screen, but will be of insufficient quality for producing a larger print. A fine Jpeg file should usually be adequate for printing up to A4 size. When a photo is taken as a Jpeg, the chosen shooting parameters (such as white balance) are applied in camera, so that the image saved on the memory card is a finished article. Although this is convenient in some ways, it allows less flexibility for adjusting the image on computer at a later stage.

Tiff files

In contrast to Jpegs which are lossy files (that is, some of the information is lost as the image data is compressed, and also each time a Jpeg is resaved), Tiff files are lossless. All the original information is saved, but of course the result is a much bigger file, so fewer images can be saved on the camera's memory card. Like a Jpeg, a Tiff file is a finished article, with the shooting parameters already applied, and this makes Tiffs much less flexible than Raw files. Rather than shooting large Tiff files which take up a lot of space without the benefit of flexibility, many photographers shoot Raw files and then save them as Tiffs or Jpegs once they have been processed.

Raw files

Unlike Jpegs and Tiffs, Raw files are not finished articles, but are 'undeveloped' – the shooting parameters have not yet been applied, but have been attached to the file so that they can be altered on a computer at a later stage. This allows for corrections to be made if necessary to white balance and exposure. Raw files are not sharpened in camera as other file types are, which means they will look soft when first uploaded, but the advantage of this is that the photographer can choose the exact amount of sharpening to be applied. Although Raw files are more time consuming to process than other file types, the advantages of flexibility and control over the final image make the extra time spent well worthwhile. Different camera manufacturers have different types of Raw file, and these can be processed using the software supplied with the camera. Once processed, the images can be saved as Tiff files, or as PSD files if using a Photoshop program. Like Tiffs, Raw files are large, and so will take up much more space on a camera's memory card than a Jpeg.

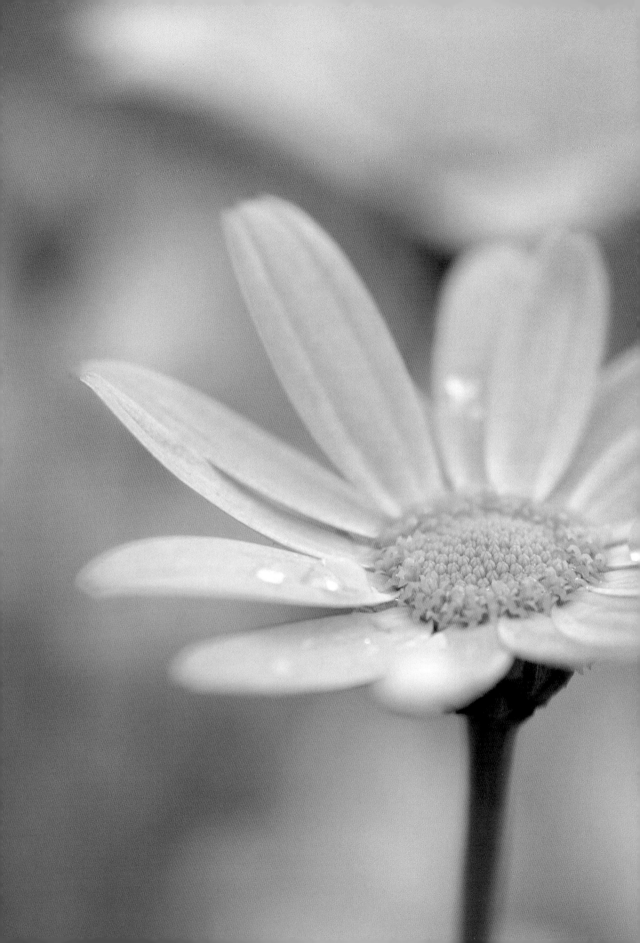

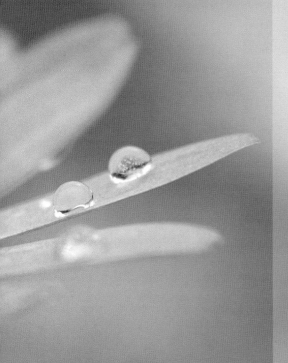

2 Lenses

Focal lengths

One of the greatest advantages of using a DSLR is the versatility of having a range of interchangeable lenses. Lenses can be either prime lenses, which are a fixed focal length; or zoom lenses, which cover a range of focal lengths. Focal lengths are generally categorized into three types: wide-angle, standard and telephoto.

In film camera terms, a standard lens is 50mm; wide-angle lenses have a focal length of less than 50mm (typically a wide-angle lens will be in the range of 24mm to 35mm); and telephoto lenses have a focal length greater than 50mm (generally between 100mm and 400mm). However, one fact the photographer needs to be aware of in relation to the focal length of any lens is the difference in focal length that the same lens may have on a film SLR and a digital SLR.

DSLRs record images on sensors, and the majority of cameras have 'cropped' sensors, which are smaller than the frame of 35mm film. This effectively increases the focal length of a lens on a DSLR by an amount which varies according to the size of the sensor. On a DSLR which has a cropping factor of 1.5x, the focal length of the lens is multiplied by 1.5, meaning that a 50mm lens will become a 75mm lens, or a 200mm lens will become a 300mm lens. On a camera which uses the Four Thirds system, focal lengths are effectively doubled, so that a 100mm lens will become a 200mm lens. Because a flower photographer will often be working at the telephoto end of the lens spectrum rather than the wide-angle end, the effect of this is usually beneficial. Cameras with full frame sensors, meaning that the focal length of lenses remains the same as with a film camera, are available but are considerably more expensive.

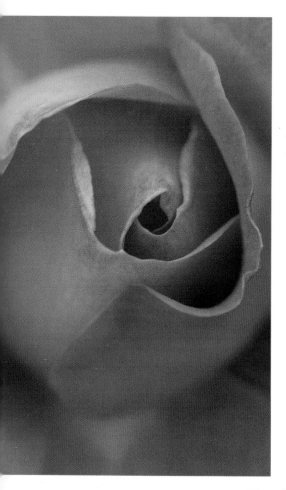

ROSE

Because my camera's sensor has a cropping factor of 1.5x, the effective focal length of my 105mm macro lens becomes just over 150mm. In most situations this is a bonus, allowing me to take frame-filling photographs of flowers from a comfortable distance.
Nikon D1x with 105mm macro lens, ISO 125, 1/180sec at f/10

Four Thirds System

This is a standard created by Olympus and Kodak for DSLR photography. It uses a smaller sensor than most other DSLRs, which effectively doubles the focal length of a lens in 35mm film terms.

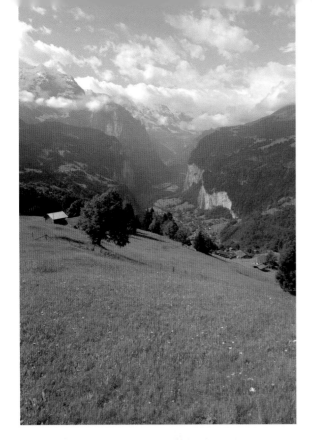

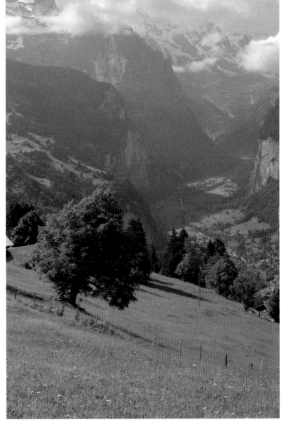

To understand the way different lenses behave, put your camera on a tripod and take a series of photos with varying focal lengths from wide-angle through to telephoto. The set of three pictures on this page shows the remarkable range available from a fairly basic set of lenses, without using any extreme wide-angle or telephoto lengths.

WIDE–ANGLE ABOVE LEFT
Nikon D1x with 12-24mm lens at 16mm,
ISO 125, 1/40sec at f/22

STANDARD ABOVE RIGHT
Nikon D1x with 28-105mm lens at 34mm,
ISO 125, 1/30sec at f/24

TELEPHOTO LEFT
Nikon D1x with 28-105mm lens at 90mm,
ISO 125, 1/13sec at f/29

Wide-angle

As the name suggests, a wide-angle lens takes in a wide field of view, and it has a shorter focal length than a standard lens. It is often used in landscape photography to give a sense of distance and space and to enhance dramatic skies. This is perhaps the lens I use least for flower photography but there are occasions when it is useful, particularly when you want to show flowers growing in their environment. A friend recently told me that she was frustrated in her attempts to photograph a tiny flower which grew on a ledge on a cliff because the resulting picture didn't give a sense of scale and the fragility of the flower in its environment. The answer to this was to use a wide-angle lens to include the flower together with the cliff face and the sea.

In the photo below of the rust-leaved alpenrose I wanted to show the flowers in their Alpine environment, so a wide-angle lens was the best choice, enabling me to include everything from the flowers in the foreground to the distant mountain peak. An aperture of f/10 was sufficient to give sharpness from foreground to background.

**RUST—LEAVED ALPENROSE
AND MOUNTAIN**
Wide-angle lenses can be used for showing a subject in its environment.
Nikon D1x with 12-24mm lens at 24mm, ISO 125, 1/350sec at f/10

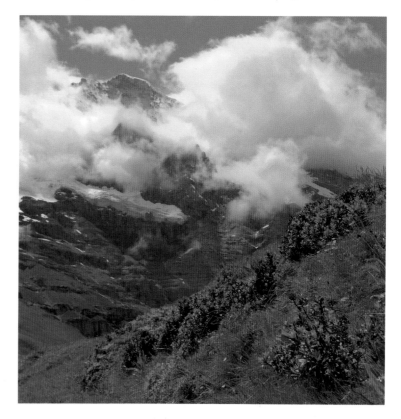

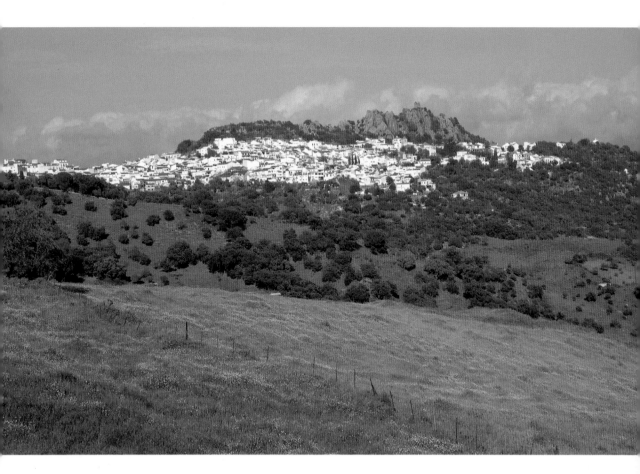

BUTTERCUP MEADOW, ANDALUCIA
Standard lenses give a natural representation of a scene with no distortion of perspective or depth.
Nikon D1x with 28-105mm lens at 38mm, ISO 125, 1/125sec at f/16

Standard

A standard lens gives a field of view which most closely approximates to the way the human eye sees – it doesn't exaggerate perspective or compress distance. It is a useful all round lens, and for the flower photographer can be good for scenes such as fields of flowers or orchards in blossom. Many standard lenses will have a reasonably good closest focusing distance, but for real close-up photography a macro lens will usually be preferable.

Prime standard lenses are not as popular as they once were, but the standard length will often be included in a zoom lens. When I saw this lovely field of flowers in Andalucia (above), I decided to use a standard length lens because I wanted to include the blue sky and the typical white town in the image as well as the flowers. This photo was taken with my zoom lens set at 38mm, which, given the cropping factor of my camera's sensor, is just about standard. The angle of view is a natural one with no distortion.

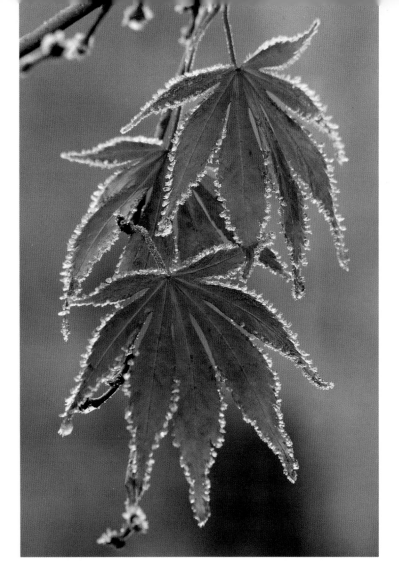

ACER LEAVES WITH FROST

These frosty acer leaves were quite high up, and it took a focal length of 360mm on my telephoto zoom lens to get a frame-filling image. Notice how the background has become a pleasing blur of colour due to a combination of the length of the lens and a relatively wide aperture.

Nikon D1x with 80-400mm lens at 360mm, ISO 125, 1/25sec at f/11

WATER LILY OPPOSITE

It's not always possible to get close enough to your subject to use a standard or macro lens, especially in the case of aquatic plants such as this water lily! Using a short telephoto lens of 105mm enabled me to take a frame-filling shot of my subject from the edge of the pond.

Nikon D1x with 105mm macro lens, ISO 125, 1/50sec at f/5.6

Telephoto

Telephoto lenses have longer focal lengths than standard, and have the effect of seeming to bring distant objects closer, and compressing perspective, in just the same way as a telescope. The longer the focal length of the telephoto lens, the more exaggerated this effect becomes. These lenses can be very useful for flower photography in various situations, especially when a particular blossom or leaf is growing high on a tree, or in a situation when the photographer can't get close enough to the subject to use a macro lens. Another advantage of telephoto lenses is that because they have a narrower field of view, they include a smaller area of background behind the subject, which means that distracting clutter behind the flower can be minimized, especially when a wide aperture is used (see page 60).

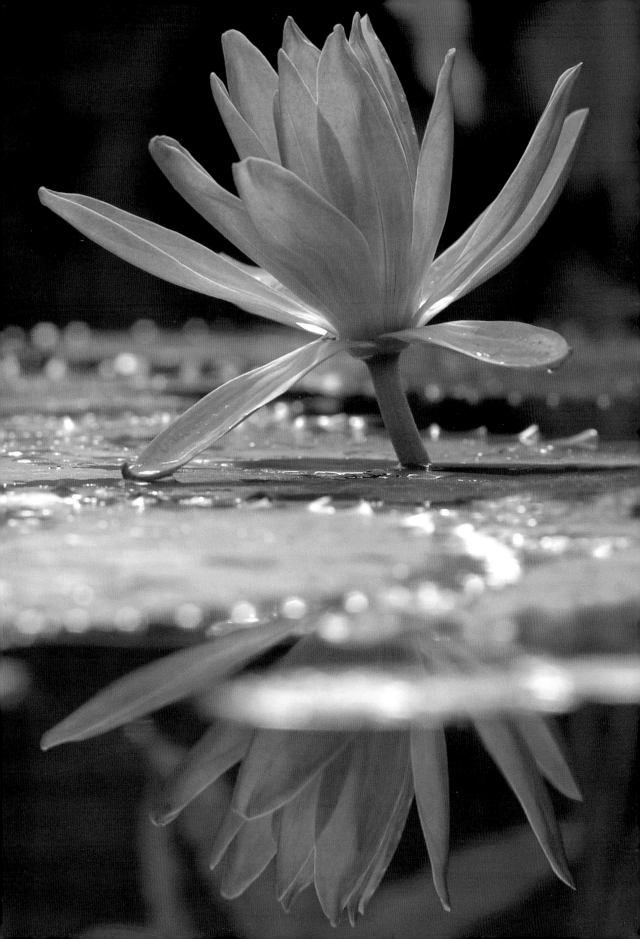

Macro

For anyone who is serious about flower photography, a macro lens is – if not actually a necessity – certainly very desirable. Macro lenses have closer focusing distances than regular lenses, and give greater image magnification, with many modern macro lenses offering a magnification of 1:1, which gives a life-size reproduction. Macro lenses come in a variety of focal lengths, which have different benefits. The shorter lenses (often around 50mm) are smaller and lighter, and are good for situations when it is possible to get right up close to the plant being photographed. However, there are situations where the extra length of a telephoto macro lens is useful – although these are heavier, they make it possible to take frame-filling photos of flowers from further away. They are useful for separating a flower from its background by throwing the background out of focus.

ASTRANTIA

I used my 105mm macro lens to photograph these astrantia flowers, and chose a wide aperture to throw the greenery behind them out of focus, producing a gentle backdrop for the flowers.

Nikon D1x with 105mm macro lens, ISO 125, 1/160sec at f/7.1

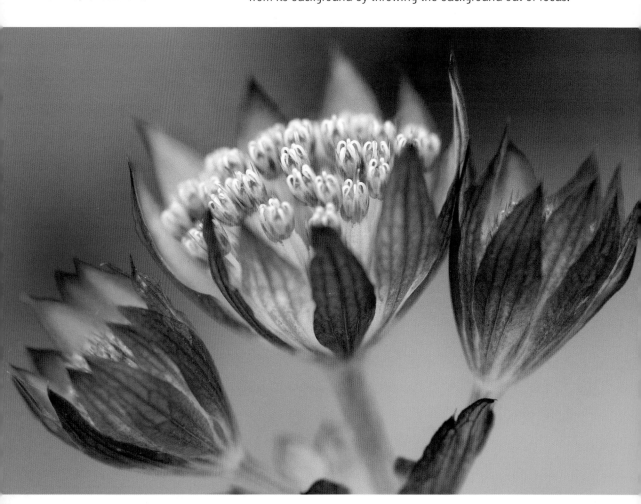

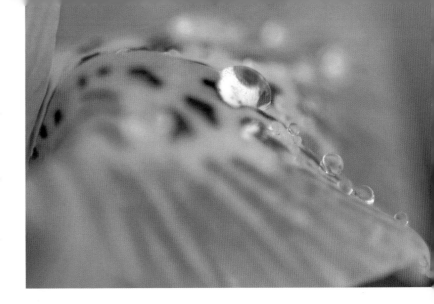

IRIS WITH WATER DROPS

Macro lenses are able to focus so closely that you see things in more detail than you would usually, allowing a whole new world of discovery. This tiny miniature iris was growing at ground level and this particular petal was less than one inch in length. I lay on the ground and used my macro lens at its closest focusing distance, enjoying the colours of the petal and the effect of the bright water droplets.

Nikon D1x with 105mm macro lens, ISO 125, 1/180sec at f/5

ACER LEAVES

A macro lens can be used for general photography as well as close-up. My 105mm macro lens was used for both of these photographs – my eye was drawn by the lovely colours of the spring acer leaves against the sky, and my first picture was the overall view; but then I went in close and used the lens's widest aperture and closest focusing distance for some rather more creative interpretations of the leaves.

RIGHT **Nikon D1x with 105mm macro lens, ISO 125, 1/180sec at f/5, exp comp +0.7**
BELOW **Nikon D1x with 105mm macro lens, ISO 125, 1/640sec at f/5**

3 Supports and Accessories

TRIPODS

BEAN BAGS

FLASH

FILTERS

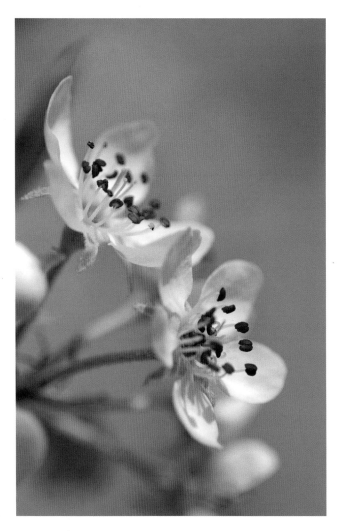

Tripods

There is no denying that tripods are heavy and cumbersome to carry, but they do have several great advantages. One is that they eliminate the risk of camera shake, a risk that is always greater when using longer lenses and larger magnifications. Secondly, they allow fine-tuning of the composition, with every aspect of the image being considered and the balance of the photograph evaluated. Thirdly, and very importantly for close-up flower photography, they enable very precise focusing. The available depth of focus at very close focusing distances is small (see Chapter Five), so even a tiny movement forwards or backwards when hand-holding can mean that the part of the picture you wanted to be sharp goes out of focus.

Many different types of tripod are available, but for flower photography it's best to choose one which can be adjusted to take photographs at ground level. Benbo and Gitzo both make tripods which can do this. It can take a while to learn how to manoeuvre them into the position you want, but the results are worth the effort! The tripod should be sturdy too – a lightweight tripod may be too flimsy to support a heavy DSLR with a long lens attached. Carbon fibre tripods are available which are lighter than conventional tripods while still giving good stability – but they are also more expensive.

PEAR BLOSSOM

With the camera held steady on a tripod, I was able to focus very precisely on the stamens of these pear blossoms. Because I had selected a wide aperture, a tiny movement forwards or back if I had hand-held the camera would have thrown them out of focus.

Nikon D1x with 105mm macro lens, ISO 125, 1/3000sec at f/3.5

Pro Tip

Make sure you buy a tripod head that is really designed for photography, not for video – some video heads do not give the full range of movement. Most heads are either of the ball and socket variety or the pan-and-tilt variety, and it's a matter of personal choice which you find easiest to use. Personally, I use a pan-and-tilt head as it allows for very precise adjustments to the composition.

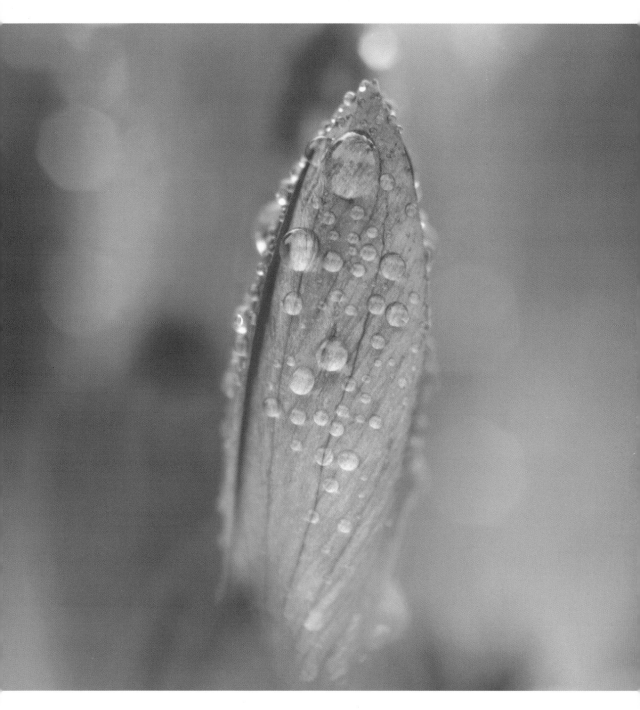

PURPLE CROCUSES WITH RAINDROPS
For photographs of low growing flowers such as this crocus, a tripod
which can be adjusted to take photographs at ground level is a great
help, especially when very precise focusing is required.
Nikon D1x with 105mm macro lens, ISO 125, 1/50sec at f/5

Bean bags

There are occasions when you may not be able to take a tripod with you, and a bean bag can be a lightweight alternative, although generally only for ground level photography, unless there happens to be a handy wall or other object at the right height to rest it on. The bean bag can be put on the ground and the camera rested on top of it. As when using a tripod, a cable release or remote control should be used to release the shutter for best results.

If you don't have a tripod or a bean bag available, try resting your camera on a folded-up jacket or even on your camera bag. If all else fails, for ground level shots you can lie on your front and brace yourself on both elbows while hand-holding the camera. If you are likely to be doing ground level photography, consider keeping a plastic bin bag in your camera bag – it's probably the cheapest piece of kit you will ever own, and if the ground is wet you can lie on it and save yourself from getting very damp!

Flash

I prefer to use natural light wherever possible, but there may be occasions where the natural light is so dull, especially when photographing inside a greenhouse or other building, that even though a picture could be taken with the camera on a tripod, the result would be rather flat. In these circumstances a burst of fill-in flash can lift the resulting image.

Many cameras have a built-in flash, or a supplementary flash can be attached to a hotshoe on the camera. Photographers who use flash often for close-up work may consider buying a specialist macro flash such as a ring flash, which gives an even, shadowless light. Beware of the fact that if your flash illuminates your subject flower, but 'falls off' before it reaches the background behind it, the background will look dark in the resulting image.

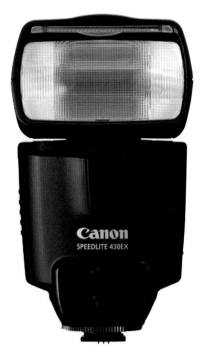

FLASH
A supplementary flash can be useful when the natural light is too dull.

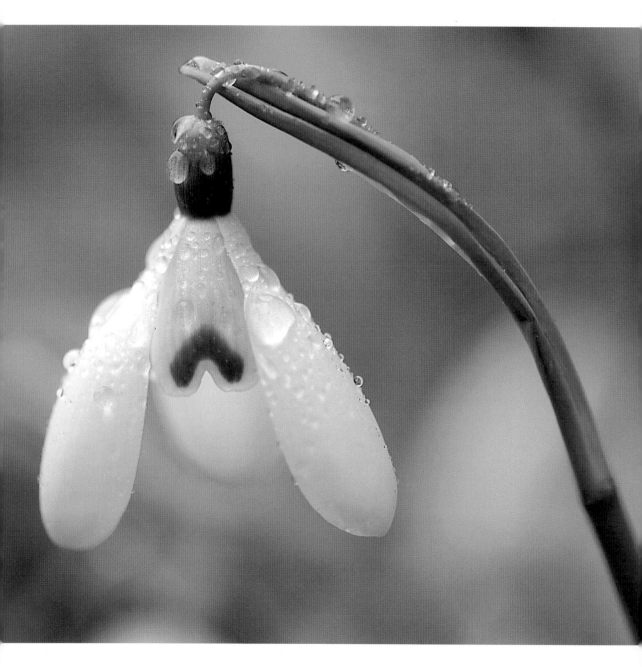

SNOWDROP WITH RAINDROPS

A bean bag can be very handy for photographing
small flowers, such as this snowdrop, at ground level.
**Nikon D1x with 105mm macro lens, ISO 125,
1/100sec at f/4.5, exp comp +0.7**

Pro Tip

It is a very good precaution to buy a skylight or UV filter for every lens you own and to keep it on the lens at all times. These clear filters do not affect the image, but they protect the front element of your lens from scratches.

WHITE CHERRY TREE

This beautiful cherry tree in the RHS garden at Wisley was at its best on this April morning. I used a polarizing filter to intensify the blue of the sky, and also to saturate all the colours in the image. The light was coming from my side, which is the ideal direction for the polarizing filter to have its maximum effect.

Nikon D1x with 28-105mm lens at 46mm, ISO 125, 1/10sec at f/25, polarizer

Filters

Film camera users will be familiar with the use of various filters, many of which were used to adjust colour temperature, notably the warm-up series of filters. These warm-up filters are largely redundant for digital photography, for two reasons: firstly, the colour temperature can be adjusted in the camera's white balance settings (see page 52); and secondly further fine-tuning of the colour can be done afterwards on the computer.

However, there is one type of filter that is still useful for the digital flower photographer – and this is the polarizing filter. These are best known for intensifying a blue sky, which is especially effective when there are white clouds in it, but they also saturate colours generally by removing white light reflections, so they can be useful when photographing a flower with waxy, shiny petals, or for foliage. A polarizer works best when the light is to the side of the photographer rather than in front or behind, and the amount of polarization can be varied, with the effect being seen by turning the ring of the filter while looking through the viewfinder.

There are two types of polarizing filter: linear and circular. If you ever use auto focus you will need the circular type. Bear in mind that using a polarizer at full polarization gives a two stop loss of light, which could be a problem if there is any subject movement caused by the wind.

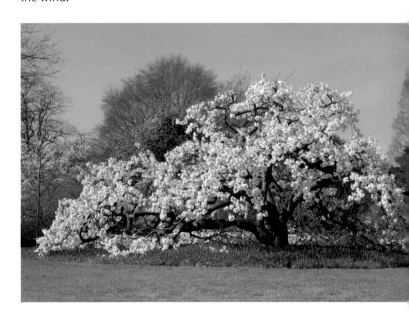

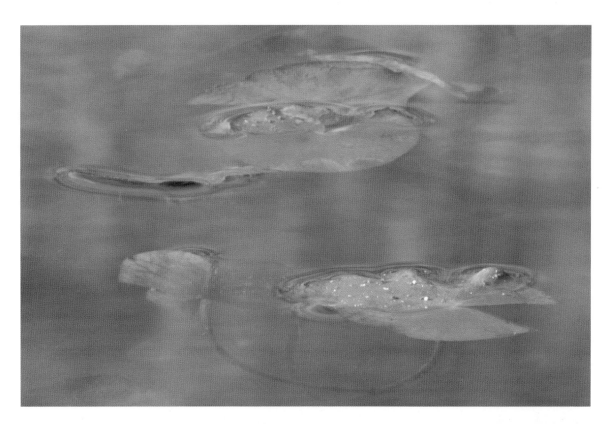

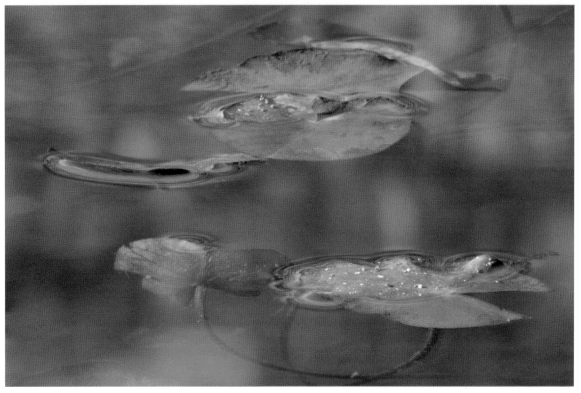

The annual miracle of the twisted, gnarled branches of fruit trees bursting almost overnight into a froth of snow white and sugar pink blossom never fails to lift my spirits and make me reach for my camera. Cherry blossom is my favourite of all and also one of the earliest to appear. After the long flower-less winter months, a morning spent photographing cherry blossom is a real joy. But while you may be delighting in the warmth of the sun and the knowledge that spring has come at last, the camera can only make an objective record, and care and thought are needed to produce an image that will evoke the joy you felt among the blossoming trees.

Cherry blossom petals are very fragile and easily damaged, and the first thing to do before taking any photographs is to select an unblemished flower. This may sound obvious, but our eye and brain will register the general beauty of a flower and disregard small blemishes, whereas the camera will record them unforgivingly. Although it is, of course, possible to clone out small imperfections on a computer afterwards, petals that are past their best and starting to curl at the edges are probably beyond the reach of computer correction.

As always, the quality of the light is crucial to the success of the image. Because blossom is so delicate, harsh bright sunlight can cause burnt out highlights as well as unsightly shadows cast by one flower onto another. The ideal light is soft but bright, on a day with a high thin layer of cloud. The other very crucial weather consideration is the strength of the wind. It can be very frustrating trying to focus and compose a photograph when the delicate flowers are continually moving and fluttering in the breeze. When I'm planning an outing to photograph blossom, the wind strength in the weather forecast is as important as any other consideration.

As in any flower photography, the choice of background to your chosen blossom can make a great difference to the resulting image. Try to avoid unsightly bare twigs, or any very bright or dark patches behind your flower. Sometimes the blossom will look at its best against a backdrop of blue sky, or it can also be lovely to use a background of similar flowers, using differential focus to separate the subject flower from those behind it.

The light was beautiful in the early morning of this March day, and as an added bonus there was no wind. The conditions were perfect for photographing this *Prunus Accolade*, one of my favourite cherry blossoms. **Nikon D1x with 105mm macro lens, ISO 125, 1/1250sec at f/3.5**

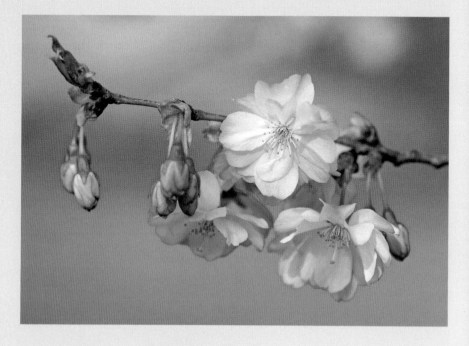

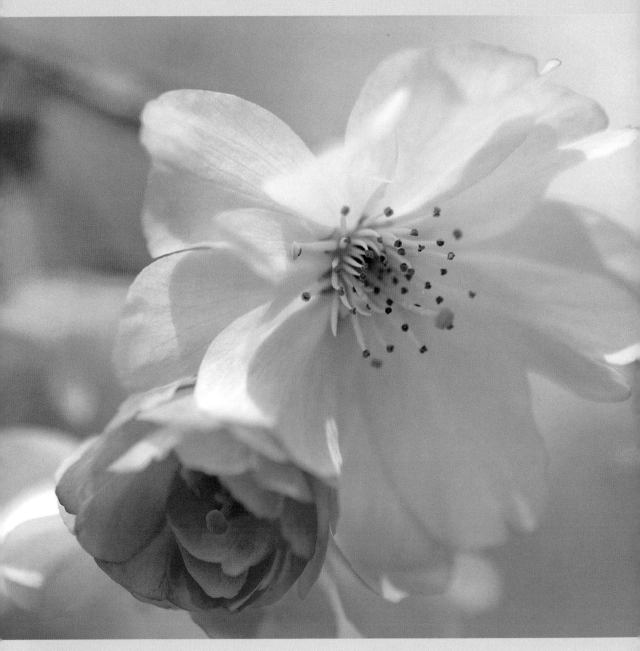

For a close-up shot such as this one, choose a perfect flower, as any tiny imperfections will be glaringly obvious at this magnification. The fragile blossoms are easily damaged by wind or rain. **Nikon D1x with 105mm macro lens, ISO 125, 1/1250sec at f/4**

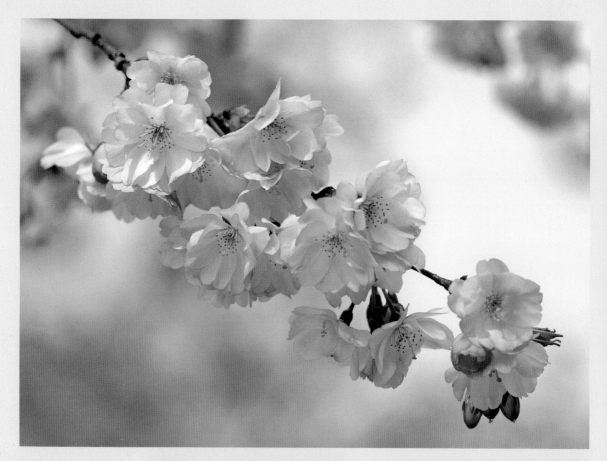

A very small change in my position has resulted in quite a different effect in these two images of the same branch of cherry blossom. Always move around your subject and evaluate the different possible backgrounds to your flowers.

ABOVE **Nikon D1x with 105mm macro lens, ISO 125, 1/800sec at f/4.5**

RIGHT **Nikon D1x with 105mm macro lens, ISO 125, 1/500sec at f/5**

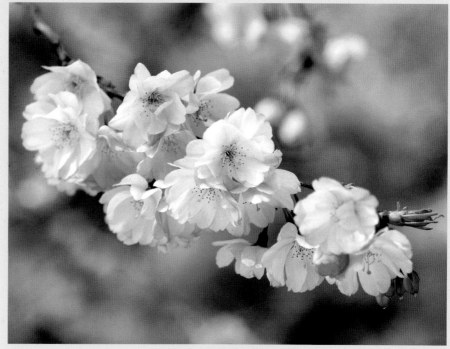

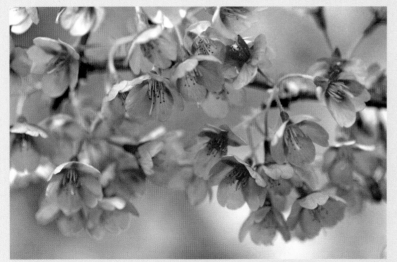

I photographed this blossom on a rather breezy day, so I waited with my camera on a tripod for the occasional moments of stillness to take my photographs. Although these two images are otherwise almost the same, it's interesting to see how the different backgrounds, as the white cloud blew past and blue sky appeared, affect the resulting image.

Nikon D1x with 105mm macro lens, ISO 125, 1/640sec at f/3.2

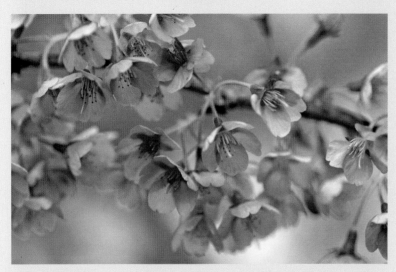

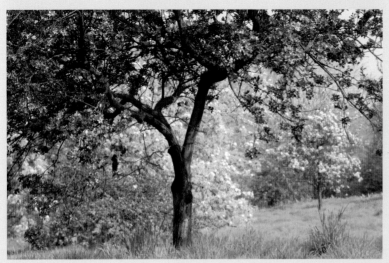

CHERRY TREE

It's not always easy to photograph the whole of a cherry tree without including details around or behind it that detract from the image. In this case, however, the whole scene was a delight, and I enjoyed being able to include three different coloured blossoms in the same photograph.

Nikon D1x with 105mm macro lens, ISO 125, 1/160sec at f/8

4 Exposure

APERTURE AND SHUTTER SPEED

ISO

WHITE BALANCE

Aperture and shutter speed

ORCHID

This set of pictures shows the effect of over and underexposure on a photograph. In the picture opposite the exposure is correct – the colours look natural, and there is detail even in the lightest parts of the petals. The picture below left is overexposed by one stop, and as a result the lightest areas have burnt out and lack detail. The picture below right is underexposed by one stop, and as a result the colours look muddy and the overall effect is too dark.

OPPOSITE **Nikon D2x with 105mm macro lens, ISO 100, 3sec at f/32**

BELOW LEFT **Nikon D2x with 105mm macro lens, ISO 100, 7.1sec at f/32**

BELOW RIGHT **Nikon D2x with 105mm macro lens, ISO 100, 1.3sec at f/32**

Modern cameras have highly sophisticated exposure meters, and it can be tempting to set the camera to automatic exposure mode. However, if your camera offers a choice of exposure modes where some of the decisions are left to the photographer, then it is possible to have more creative control over the final image by making an informed choice about aperture and shutter speed.

To make a correctly exposed image, the right amount of light must be allowed to enter the camera, and this is controlled by two settings, the shutter speed setting and the aperture setting. The shutter speed setting controls the amount of time the shutter is open, measured in fractions of a second. The aperture setting controls the size of the aperture in the lens, and these settings are expressed as f-stops. The two settings are in a balanced relationship with each other, so that each time the shutter speed is increased by one stop, the aperture must be decreased by one stop to maintain the same exposure, and vice versa.

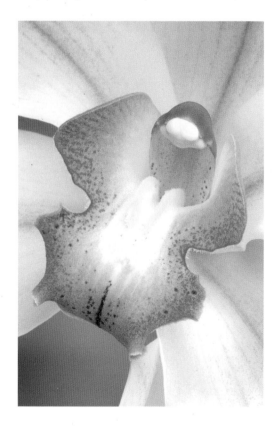
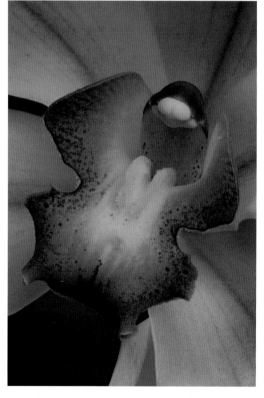

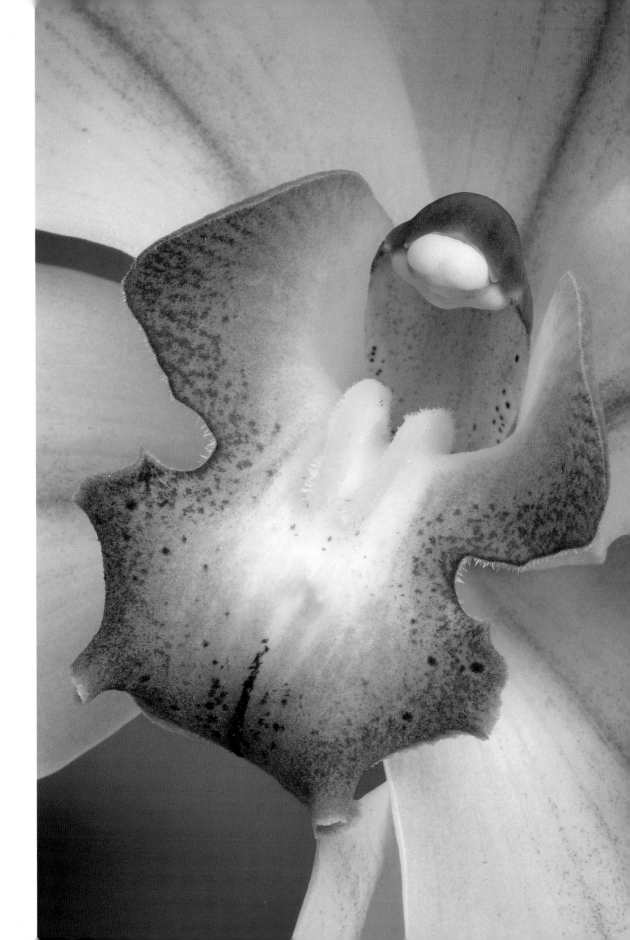

The exposure mode which I prefer to work with for flower photography is aperture priority, which means that the photographer chooses an aperture, and the camera sets the appropriate shutter speed to give a correctly exposed photograph. The choice of aperture is crucial to the amount of the image that is in sharp focus (see page 60), and because this is one of the most important decisions to make in any photograph, I make that my priority rather than shutter speed.

Of course, if I am photographing in windy conditions, I keep an eye on the shutter speed that the camera is giving for my chosen aperture to make sure that it is short enough to prevent subject movement, and adjust the choice of aperture if necessary.

I wanted a very wide aperture to give a shallow depth of field in this photograph. Using my camera on aperture priority, I chose the aperture and the camera selected the shutter speed which would give a correct exposure. Had I used the camera on auto, it would have picked a mid-range aperture instead of the widest one, and the resulting image would have been quite different.

Nikon D1x with 105mm macro lens, ISO 125, 1/4000sec at f/3.8

The other semi-automatic exposure mode is shutter priority, where the photographer chooses the shutter speed and the camera selects the appropriate aperture. Alternatively, both aperture and shutter speed settings can be made manually, and in this case a light meter will be necessary to determine the correct exposure.

A long shutter speed may result in a blurred image due to camera shake if the camera is hand-held. As a general rule of thumb, the longest shutter speed at which the camera can safely be hand-held is equivalent to the focal length of the lens, for instance a 50mm lens can be hand-held for 1/50 second or less, and a 300mm lens can be hand-held for 1/300 second or less. At high magnifications the risk of visible camera shake is higher and a faster shutter speed should be selected.

There will be some occasions when the camera's TTL (through the lens) meter will be fooled into choosing incorrect exposure settings. These are generally when your subject is extremely light or extremely dark, and fills most of the image frame. The camera expects the overall light and dark tones of an image to average out to a mid grey, and therefore it may underexpose a white subject or overexpose a black one. To avoid this, the exposure can be adjusted, and this is most easily done by using the exposure compensation button or dial. For a white flower which is filling most of the frame, I would add between half a stop and a stop of exposure. If in doubt, bracket your exposures by taking the recommended exposure plus one or two more either over or under it in half stop increments.

Bracketing

If you are taking a photograph in a tricky lighting situation and you think that the camera's meter may not choose the correct exposure, you can bracket your exposures. This is usually done via the camera's exposure compensation button or dial. You can set this to take one or more photographs at a third of a stop, half a stop, or a full stop over or under the camera's suggested exposure.

PEAR BLOSSOM RIGHT

Because I had filled the frame with this
white pear blossom, I knew that I would
have to add exposure to the camera's
suggested settings to achieve a correct
result. This picture was taken with exposure
compensation of plus one stop.

**Nikon D1x with 105mm macro lens, ISO
125, 1/2500sec at f/3.5, exp comp +1**

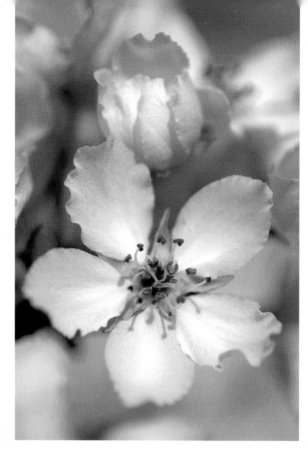

PLUM BLOSSOM BELOW

A white flower will not necessarily require
exposure compensation if it doesn't fill
the whole of the image area. Although
this plum blossom was white, there were
enough darker areas in the picture for the
camera's suggested exposure settings to
be correct.

**Nikon D1x with 105mm macro lens,
ISO 125, 1/1000sec at f/5.6**

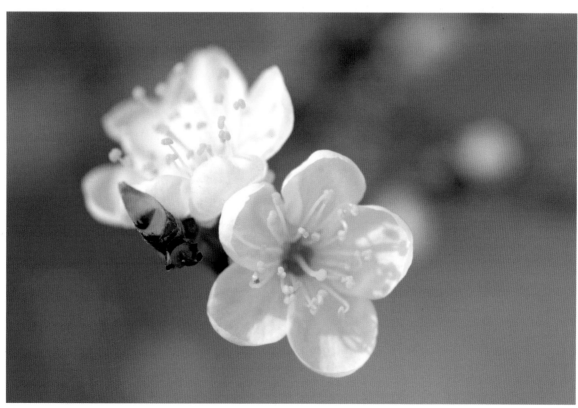

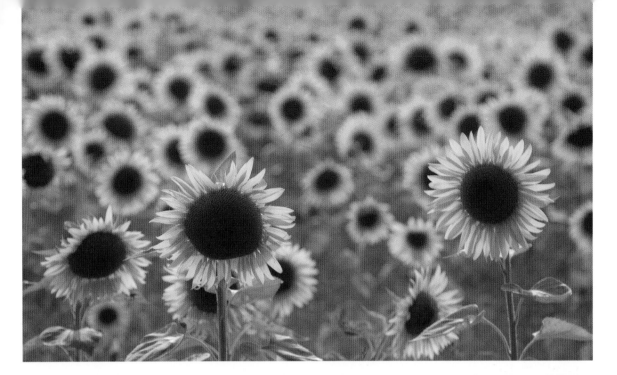

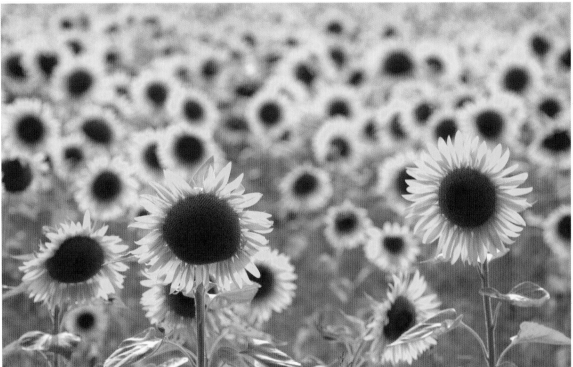

BACKLIT SUNFLOWERS

Another situation which may fool a camera's meter into underexposing is when the subject is brightly backlit. The first of these photos of a field of backlit sunflowers was taken at the camera's suggested reading, but in the resulting image the colour of the petals is rather dull and muddy. The second photo was taken at one stop over the suggested reading, and this has restored the brightness and vibrancy to the flowers.

TOP **Nikon D1x with 80-400mm lens at 165mm, ISO 125, 1/640sec at f/5.** ABOVE **1/320sec at f/5, exp comp +1**

ISO

In addition to choice of aperture and shutter speed, the third factor in the exposure equation is the ISO setting. Digital cameras have a range of ISO settings and these affect the sensitivity of the sensor to light. At lower ISO settings there is less sensitivity to light, meaning that a wider aperture or a longer shutter speed will be required to give the correct exposure than would be the case at a higher ISO setting. This means that a high ISO setting (giving more sensitivity to light) is useful for photographing in low light, or for hand-held photography, but the downside of a high ISO is an increase in noise. Randomly spaced, brightly coloured pixels in an image are known as noise,

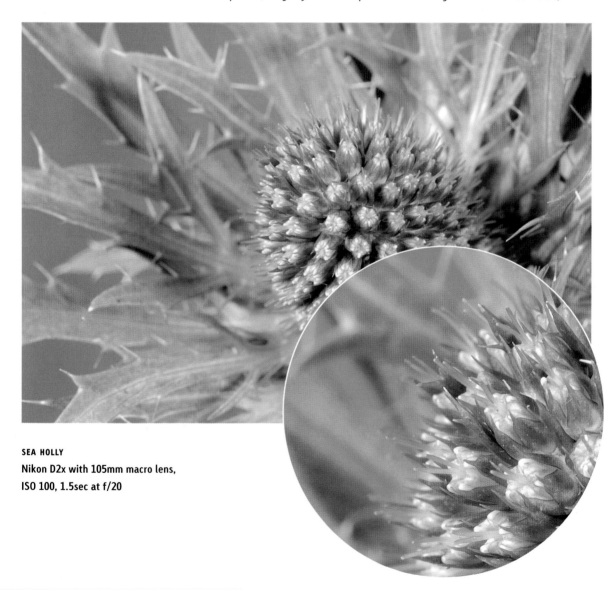

SEA HOLLY
Nikon D2x with 105mm macro lens,
ISO 100, 1.5sec at f/20

and result in a reduction in detail and quality. For flower photographs I always use my lowest ISO setting (which is 100 on my particular camera) unless there is a definite reason to choose a higher one.

To see the effects of noise on an image, I photographed this sea holly once at an ISO setting of 100, and then again at HI-2, which is my camera's highest ISO setting and is approximately equivalent to ISO 3200.

Although the difference is not so noticeable when you see the picture at the size it is reproduced here, if you compare the magnified portions of each image, you can clearly see the reduction in quality caused by noise at the higher ISO setting.

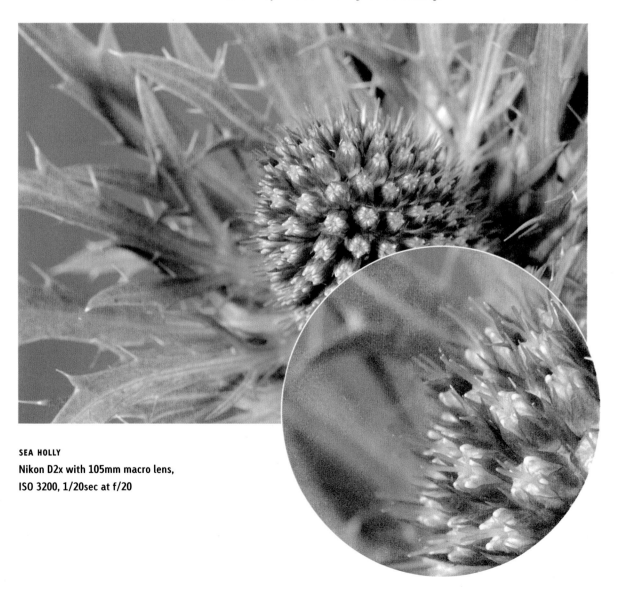

SEA HOLLY
Nikon D2x with 105mm macro lens,
ISO 3200, 1/20sec at f/20

White balance

The colour temperature of light varies considerably according to the type of light source. Our eyes and brains have a great ability to compensate for this so that we usually see everything in an apparently neutral light. The camera's sensor, however, does not compensate in the way in which our eyes do, but accurately records the effect of the colour temperature of the prevailing light on the subject, which can result in an unwanted warm or cool cast – for instance, a white flower photographed in tungsten light would have an orange cast.

To avoid this, most digital cameras have a range of white balance settings, such as daylight, cloudy, shade, tungsten and so on. When the appropriate setting is selected, the resulting image will appear in a neutral light, without a colour cast. There is also an auto white balance setting which is able to cope with many situations where the lighting conditions are straightforward. In addition, many DSLRs have a white balance custom preset facility, so that if studio lighting is being used, the white balance can be preset to the correct colour temperature by pointing the camera at a piece of white card under the light source being used.

FLOWER ON WALL

This little flower was growing on the shady side of a wall. Photographing in the shade on a sunny day can result in a cool blue cast, and this is evident in the first of these photos, taken with the white balance set to auto. For the second photo I set the white balance to 'shade on a clear day', and this has produced a much more natural result.

BELOW LEFT **Nikon D1x with 105mm macro lens, ISO 125, 1/20sec at f/10, white bal auto**

BELOW RIGHT **Nikon D1x with 105mm macro lens, ISO 125, 1/20sec at f/10, white bal shade**

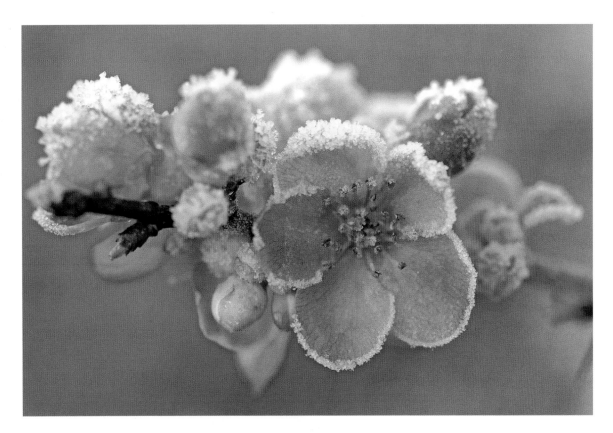

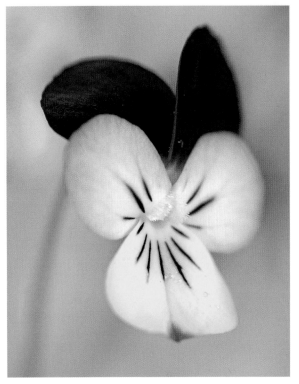

JAPONICA WITH FROST

Although this japonica was in the shade on a clear day, I decided to leave the camera's white balance setting on auto. Changing the white balance setting to 'shade on a clear day' would have had the effect of warming the colours, but in this case I felt the cool colour tones complemented the frosty image.

Nikon D2x, 105mm macro lens, ISO100, 1/100 sec at f/5

VIOLA

I photographed this little viola using my studio lights, and used a custom white balance setting which I had preset by pointing my camera at a piece of white card under the lighting set-up. This has resulted in a very natural looking colour temperature.

Nikon D1x with 105mm macro lens, ISO 125, 1/50sec at f/7.1

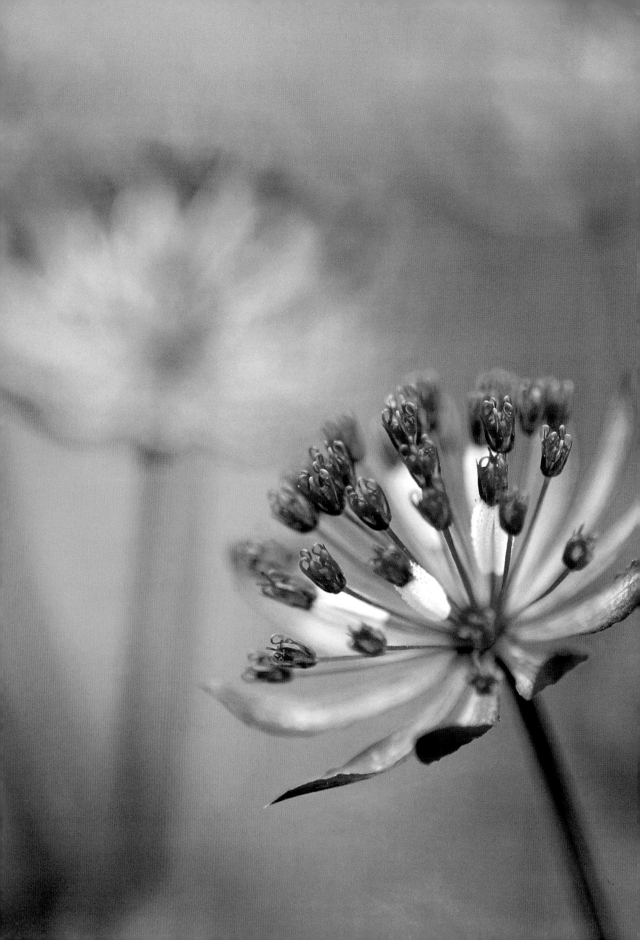

5 Depth of Field

CONTROLLING DEPTH OF FIELD

CORRECT APERTURE

Controlling depth of field

In Chapter Four we looked at the relationship between aperture and shutter speed, and how the two settings together are used to determine the exposure. I mentioned that I prefer to use my camera on the aperture priority setting, because of the importance of choosing the right depth of field for a photograph. In this section I will look at this in more detail.

Aperture settings are made either by manually turning the ring on the lens or by using the aperture dial. The settings are expressed as f-stops, and relate to the size of the aperture in the lens, which is variable and is controlled by opening or closing the lens diaphragm. The range of available f-stops will vary according to the make and length of the lens, but typically the widest aperture may be f/2.8, and the smallest may be f/32. A wider aperture (which will have a lower f-stop number) allows more light through the lens and onto the sensor, so that for any given exposure, a shorter shutter speed is needed than would be the case with a smaller aperture.

The choice of aperture directly affects the amount of depth of field in an image, that is, the amount of the image from front to back that appears sharp. With a wide aperture, there is limited depth of field,

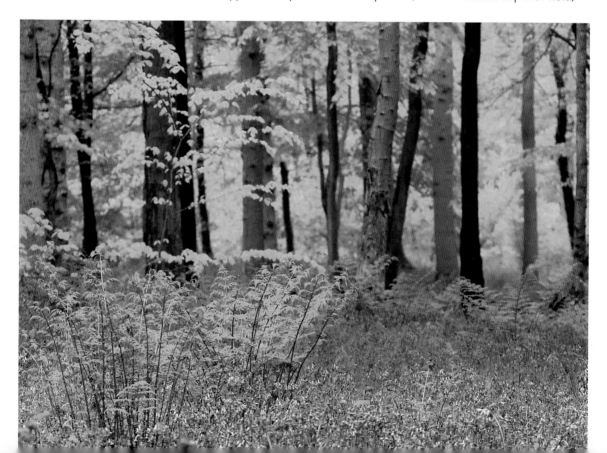

BLUEBELL WOOD

These two photos show the effect of lens length on depth of field. They were both taken from more or less the same position, with the aperture set to f/8 on my zoom lens. The first picture was taken with a focal length of 135mm, and I focused on the ferns in the foreground. Although the background trees are not completely sharp, there is enough detail in them to look distracting and messy. For the second photo, still with the point of focus being the ferns, I used a focal length of 310mm. This has dramatically reduced the zone of sharpness in the picture, throwing the background trees out of focus and providing a more impressionistic backdrop for the ferns.

LEFT **Nikon D1x with 80-400mm lens at 135mm, ISO 125, 1/20sec at f/8**

RIGHT **Nikon D1x with 80-400mm lens at 310mm, ISO 125, 1/40sec at f/8**

so that the subject focused on will be sharp while objects in front of or behind it will be unsharp. With a small aperture, there is a greater depth of field, so that more of the objects in front of and behind the subject will be in sharp focus.

The exact range of the zone of sharpness will depend also on other factors. One of these is the distance between the camera and the subject – at close focusing distances depth of field is much more limited. So the same lens used at the same aperture will give a greater depth of field in a picture of a subject which is a long way from the camera than in a picture of a subject a short distance away.

The amount of depth of field at any given f-stop will also depend on the type of lens being used, if the same subject is being photographed from the same place – the shorter the lens, the greater the depth of field. So if a photographer stands a certain distance from a tree and photographs it with a telephoto lens, the depth of field will be less than if a standard lens is used from the same place. However, if the photographer were to move closer to the tree and photograph it with a standard lens in such a way that its size in the image was the same as in the first picture with the telephoto lens, then the resulting depth of field would be the same.

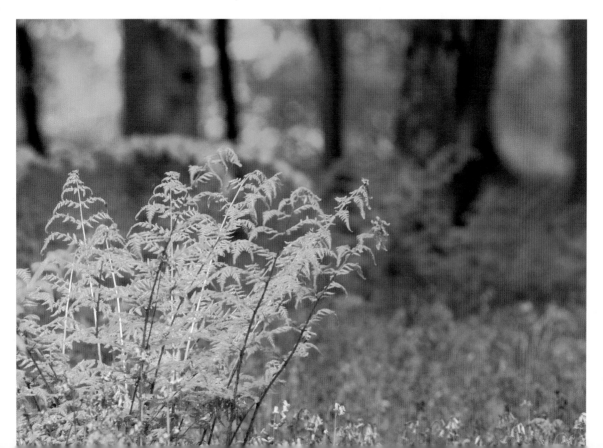

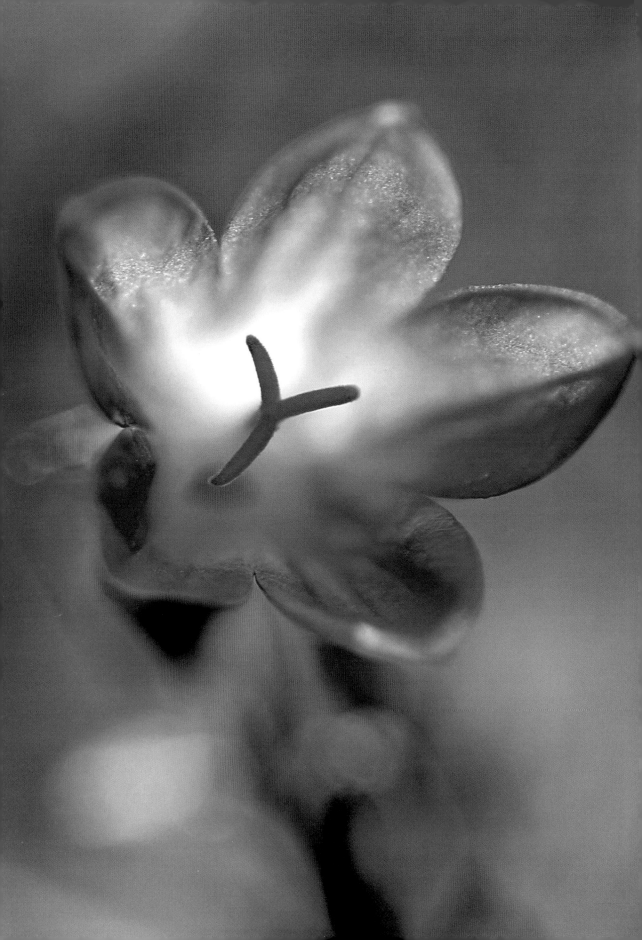

One other factor which will affect the amount of sharpness in the image is the choice of point of focus. If you are photographing a scene with objects in the foreground, midground and background, all of which you want to appear sharp, you will choose a small aperture to get the maximum depth of field. But if you were to focus on the closest objects, you would waste some of your available zone of sharpness on the space between the closest object and yourself. Similarly, if you focus on the furthest object, you waste part of your depth of field behind that. To get the maximum zone of sharpness in such a situation, it is best to focus on something between about one third and one half of the way between the closest and most distant elements in the photograph.

When focusing at very close distances with a macro lens, the available depth of field is very limited even with the lens at its smallest aperture. For this reason, it is best to use manual focus rather than autofocus, as the choice of the exact point of sharp focus is very crucial to the way the image will appear.

When you look at any subject through your lens, the image in your viewfinder is seen as it will appear at the lens's widest aperture, and changing the aperture on the lens will not alter the way the viewfinder image appears. It will alter the way the resulting photograph looks, however, so it is important to know what the effect of the different apertures will be. On older lenses there is usually a depth of field scale, which will allow you to calculate at what distance from the camera the subject will be sharp. If this is not available, or for close-up work when the scale is not sufficiently precise, a depth of field preview button is the ideal option. Many DSLRs now have one, and if you are buying a camera for flower photography I would definitely recommend making sure that depth of field preview is available on the model you choose. If you hold this button down while looking through the lens, it physically changes the aperture in the lens, so that you will be able to see exactly how much of the image will be sharp. The only drawback with this is that as the aperture gets smaller, the image in the viewfinder gets darker, so that at really small apertures it can be quite difficult to evaluate. If in doubt about which aperture to choose, take a series of photographs of your subject at different apertures and then see which result you like best.

AUBRETIA
By using a wide aperture and focusing carefully I was able to separate this tiny aubretia flower from a background of other flowers of the same colour. This technique is known as differential focus.
Nikon D1x with 105mm macro lens, ISO 125, 1/500sec at f/4.2, exp comp +0.7

Correct aperture

The importance of choosing the correct aperture and therefore having the right depth of field in a flower photograph cannot be over emphasized. There is not one correct aperture which will apply in every situation – each image has to be assessed individually, and a decision made about which parts of it should appear sharp and which parts would be better out of focus. For instance, a beautiful flower may be growing in front of a tangle of leaves and stems, and if these

ASTRANTIA

When photographing at a close focusing distance with a wide aperture, depth of field is extremely shallow. This set of three photos was taken with the camera on a tripod and the aperture set to f/3.3. Between each exposure I adjusted the focus, so that in the first photo I focused on the front flower, in the second photo on a middle flower, and in the last photo on a flower at the back of the group. You can see how limited the depth of field is, and how dramatically the photograph changes as the focusing ring is turned.
Nikon D1x with 105mm macro lens, ISO 125, 1/400sec at f/3.3

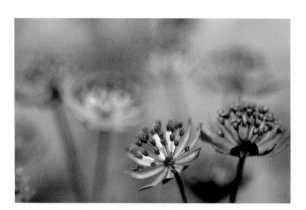

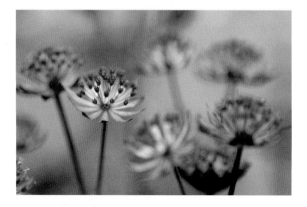

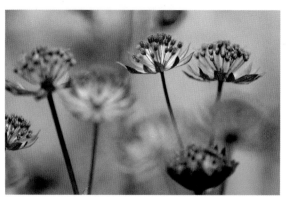

My favourite picture of these little astrantia flowers was the one below – also taken at f/3.3. I like the way the differential focus causes the background flowers to become suggested, impressionistic versions of the foreground ones.

Nikon D1x with 105mm macro lens, ISO 125, 1/350sec at f/3.3

were sharp they would distract the viewer's eye from the subject; the solution is to choose a wide aperture so that the flower is in sharp focus, but the leaves behind it are out of focus and become a gentle wash of green, enhancing the flower rather than detracting from it.

In the same way, a wide aperture can be used to separate one flower from a backdrop of other flowers of the same colour – this is known as differential focus, and is one of the most useful techniques for a flower photographer. On other occasions you may wish to have as much of the image sharp as possible, and then you would choose a smaller aperture.

Occasionally the choice of aperture will be affected by considerations regarding the shutter speed. As discussed in Chapter Four, each change of f-stop will necessitate a corresponding one stop change of shutter speed to maintain the same exposure. If you are hand-holding your camera, or if you are using a tripod but conditions are windy, you may be restricted in your choice of aperture by the necessity of not allowing the shutter speed to be so long that the image will be blurred by camera shake or subject movement.

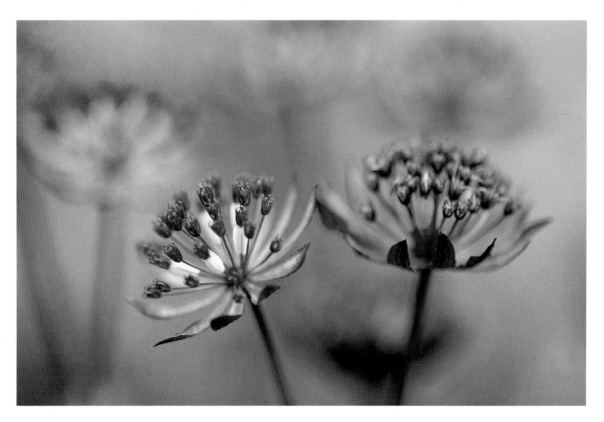

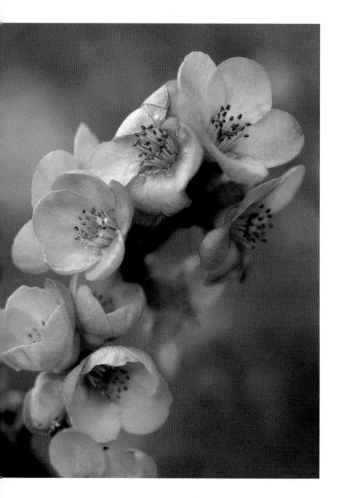

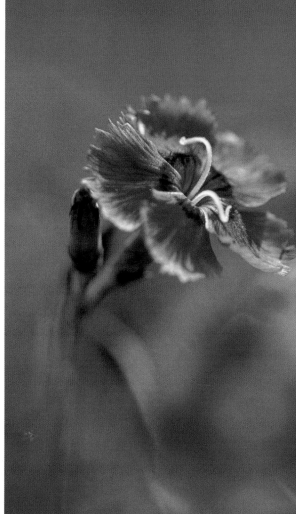

JAPONICA

I was attracted by the unusual coral colour of these japonica flowers, but their background was a muddle of other flowers and twigs. I selected an aperture of f/3.3 to defocus this as much as possible, and the result is a pleasing soft wash of coral and brown tones behind the flowers, which complement rather than distract.

Nikon D1x with 105mm macro lens, ISO 125, 1/350sec at f/3.3

DIANTHUS

I focused on a dianthus flower in the middle of several similar flowers, and chose an aperture of f/3.3. With this shallow depth of field, the flowers both in front of and behind my subject flower were thrown out of focus, resulting in a wash of pink. The blurred areas help to draw the viewer's attention to the point of sharp focus in the picture.

Nikon D1x with 105mm macro lens, ISO 125, 1/1600sec at f/3.3

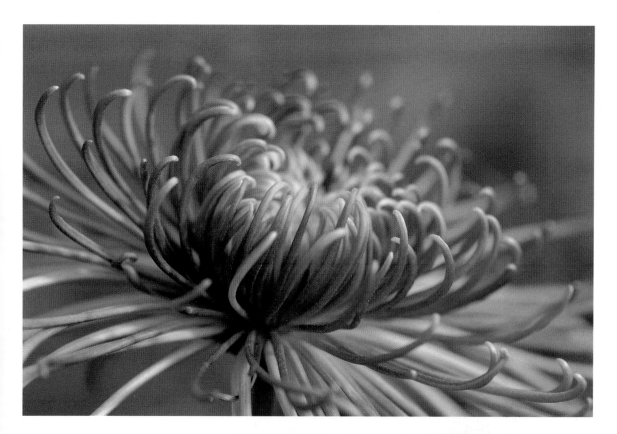

CHRYSANTHEMUM

This lovely chrysanthemum was growing in a greenhouse, and behind it were panes of glass with metal frames. By selecting a wide aperture I was able to throw the background totally out of focus so that it did not distract from the flower.

Nikon D2x with 105mm macro lens, ISO 100, 1/160sec at f/5

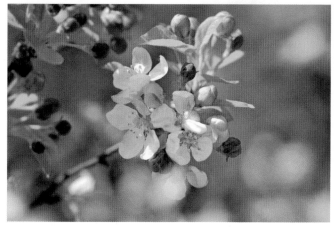

APPLE BLOSSOM

I photographed this apple blossom on a lovely spring morning, and I wanted to emphasize the feeling of spring rather than make a mere record of the blossom. A wide aperture of f/4 with a telephoto lens meant that large areas of the image were thrown out of focus, and I enjoyed moving around while looking through the viewfinder until I had the out of focus blossoms in the right balance with the sharply focused ones. The impressionistic result gives more of a sense of spring's abundant growth than a picture which was sharp all the way through would have done. In addition, it enabled me to choose some unblemished blossoms to be sharp, and not be concerned about blemishes on the out of focus ones. Apple blossom is easily damaged, and it can be hard to fill the frame with a profusion of blossom all in perfect condition.

Nikon D1x with 105mm macro lens, ISO 125, 1/800sec at f/4

BLOSSOM

I sometimes think the out of focus areas in a photograph can be just as lovely as the parts which are sharp. The branches of this apple tree were being continually tossed by the wind, and in addition were growing above a wall in a position where I couldn't really use my tripod and compose carefully. I decided to take a series of hand-held photos of the fragile blossoms at a wide aperture and hope that in some of the results the point of focus would be where I wanted it to be. (This was when I had only just acquired my digital camera and caused me to realize one of the benefits of digital – I'm not sure that I would have used a couple of films in such a haphazard way!) The very limited depth of sharp focus has produced an impressionistic, almost painterly result.

Nikon D1x with 105mm macro lens, ISO 125, 1/250sec at f/3.5

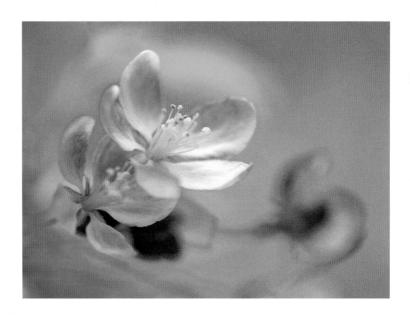

SUNFLOWERS AND TREES

Although my personal inclination is to use a wide aperture, because I enjoy the painterly effect of out of focus areas in the image, there are occasions where I feel that this would not work, and I want front to back sharpness in the photograph. On a trip to the Loire in France to photograph sunflowers, it proved surprisingly difficult to find a field of sunflowers with a good backdrop, so when I found these flowers growing in front of a line of poplars, I wanted both flowers and trees to be sharp. I therefore selected an aperture of f/36. This meant that I had to use my tripod, as the shutter speed was 1/13 second, too slow for hand-holding with my telephoto lens.

Nikon D1x with 80-400mm lens at 135mm, ISO 125, 1/13sec at f/36

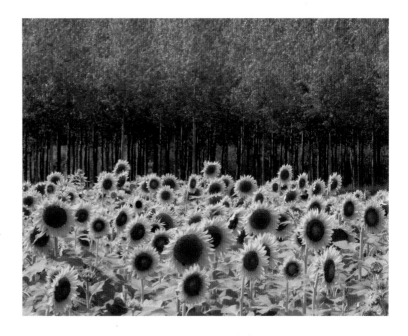

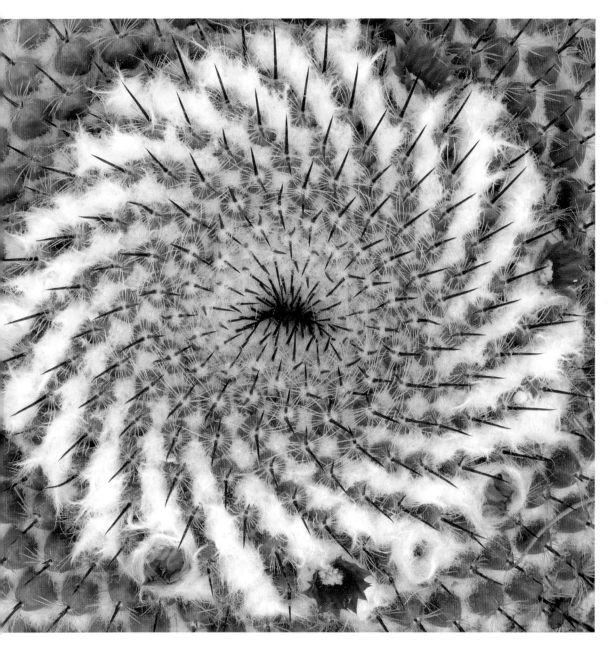

CACTUS

I wanted this photograph of the top of a flowering cactus to be sharp throughout, so I used a very small aperture to maximize the depth of field.

Nikon D2x with 105mm macro lens, ISO 100, 1/4sec at f/29

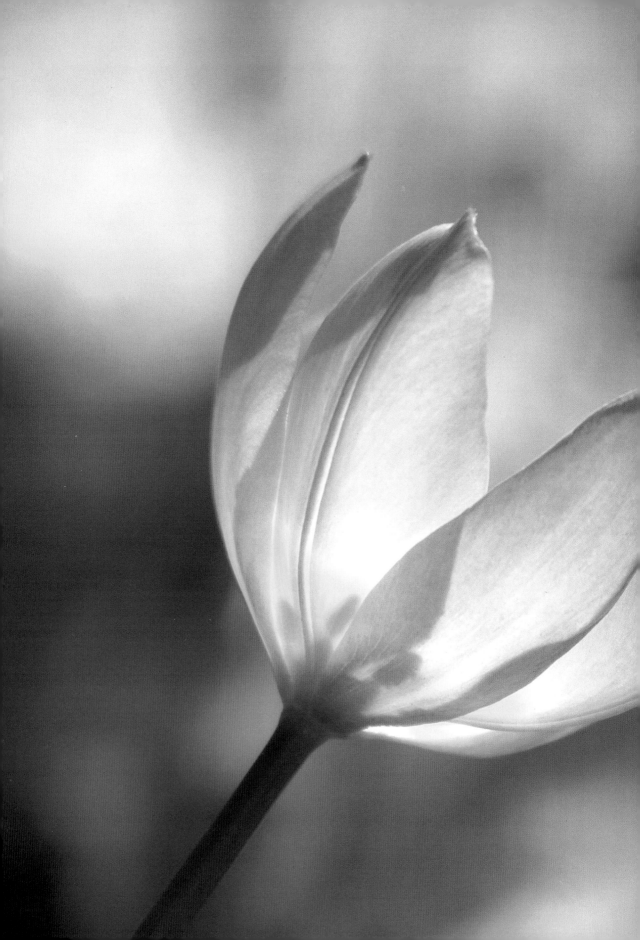

6 Light

Different types of light

In flower photography as in any other kind of photography, the quality of light is one of the most vital elements to consider. While we may often be unable to control the lighting conditions present when we are taking a picture, an understanding of the different types of light and the way they will affect the resulting image at least enables us to make the best use of the conditions available. The wrong lighting can spoil a photograph of even the most beautiful flower; on the other hand, good lighting can enhance your subject and even transform an otherwise ordinary picture.

Direction

The same flower will appear quite differently in light coming from different directions. Front light (the light that occurs when the sun is behind the photographer and so falls directly onto the front of the flower) is not usually the most flattering light – it doesn't reveal any texture in the plant, and tends to illuminate any blemishes in petals rather harshly.

Side lighting will reveal texture and make the subject look more three-dimensional than front lighting does. The effect of back lighting (when the flower is between the photographer and the sun, so the light is shining through the flower towards the photographer) varies considerably depending on the type of plant. If it is a flower with translucent petals, the effect can be lovely, as the petals are illuminated by the light behind them and their colours glow. However if it is something solid, such as a tree trunk, it may be underexposed in a backlit situation.

Writing with light

The word photography derives from Greek and can be literally translated as 'writing with light'. Light is an essential part of photography, and the more you can understand about its different qualities, the better use you will be able to make of it in your images.

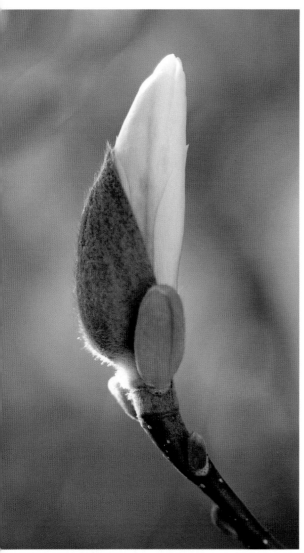

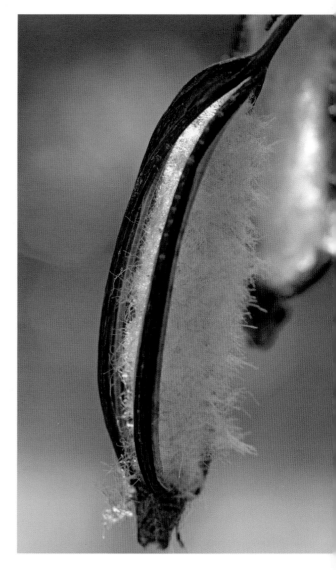

MAGNOLIA BUD

It was a sunny day when I was photographing this magnolia, but I didn't want any direct sunlight to fall on the white petals as that might have caused burnt-out highlights. By positioning myself so the sun was in front and slightly to the side of me, the detail in the petals has been retained, and a slick of side lighting on the edge of the bud has enhanced the furriness of the bud's outer casing.

Nikon D1x with 105mm macro lens, ISO 125, 1/1000sec at f/3.2

SPIDER ORCHID SEED POD

The use of backlighting helps to reveal the texture of these spider orchid seed pods. A wide aperture was used to throw the background out of focus.

Nikon D1x with 105mm macro lens, ISO 125, 1/500sec at f/5

BACKLIT TULIPS

The use of backlighting on a flower with translucent petals, such as this tulip, enhances the colours of the petals and the patterns made where they overlap. Together with the use of differential focus (see page 61), it also helps to set the flower apart from the other similar flowers behind it.

Nikon D1x with 80-400mm lens at 400mm, ISO 125, 1/350sec at f/7.1

Flare

One thing to be aware of when using backlighting is the danger of flare. This can happen when sunlight falls directly onto the camera's lens, and results in overall degradation and sometimes bright spots of light in the image. The easiest way to avoid this is to use a lens hood – if light still falls on the lens, then shade the lens with your hand or a piece of card. In this case you will need to have the camera on a tripod unless you have a companion to do the shading for you!

Although this Alpine scene (below) was sidelit rather than backlit, the sun was just enough in front of me to fall on my lens and cause flare in the first of these pictures. You can see how this has completely degraded the bottom right corner of the image. My camera was on a tripod, so for the second picture I shaded the lens with a piece of card to avoid the flare.

VERSION ONE BELOW
Nikon D1x with 28-105mm lens at 40mm, ISO 125, 1/13sec at f/25

VERSION TWO BELOW RIGHT

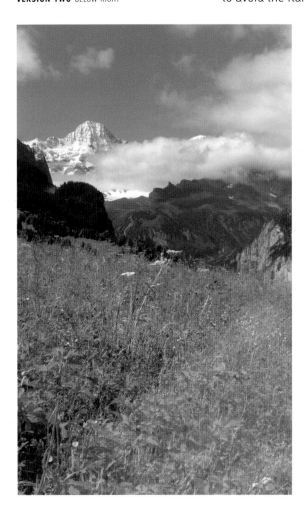

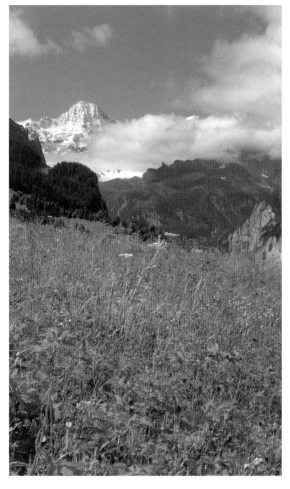

Quality

There are many different types of light, varying from the harsh overhead light at noon on a bright summer's day, through gentle side lighting on a misty morning, to the dull, overcast light of a day with heavy cloud.

Bright sunlight

The effect on a photograph of bright sunlight depends very much on the time of day and the direction of the light. At midday in the summer when the sun is directly overhead, the light is quite hard and unflattering to many flowers. Our eyes make allowances for the contrasty nature of this type of light, and can see detail in both the highlight and shadow areas; but the camera can't do this, and if the range of contrast is too great, white or light coloured petals may look burnt out, while areas of shadow, even just the shadow thrown by one petal onto another, will look dark and unsightly. However, when the sun is lower in the sky, bright sunlight can be used to more advantage, particularly for backlighting. Flowers that lend themselves well to backlighting tend to have fairly strong colours and bold shapes, for example tulips or sunflowers. Deep throated flowers, such as lilies, don't work so well with backlighting and nor do delicate light coloured flowers such as cherry blossom, which need a gentler light.

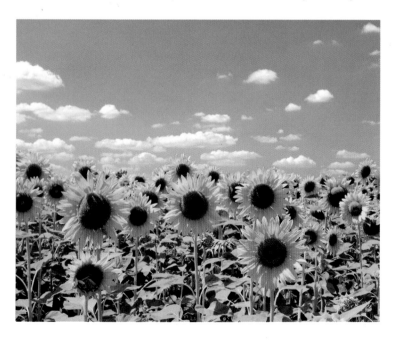

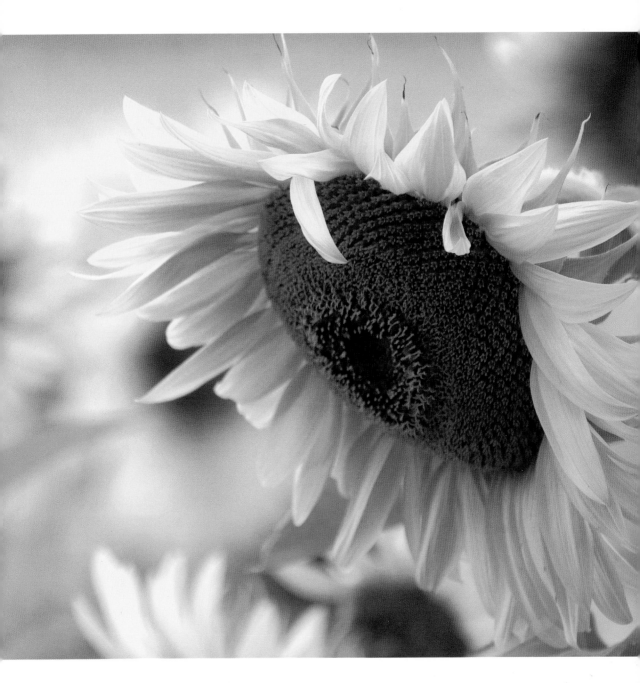

SUNFLOWERS OPPOSITE AND ABOVE
The photograph of sunflowers on a
bright sunny day when the sun was
high in the sky works mainly because
of the lovely contrast between the
yellow flowers and the blue sky, and
the added bonus of fluffy white clouds,
emphasized by using a polarizing filter.

Nevertheless, you can see that the light
is quite harsh on the flowers and leaves
and I prefer the gentle light in the
second photograph, taken when a thin
layer of cloud was covering the sun.
OPPOSITE **Nikon D1x with 28-105mm
lens at 34mm, ISO 125, 1/20sec
at f/20**

ABOVE **Nikon D1x with 80-400mm lens
at 400mm, ISO 125, 1/90sec at f/5.6**

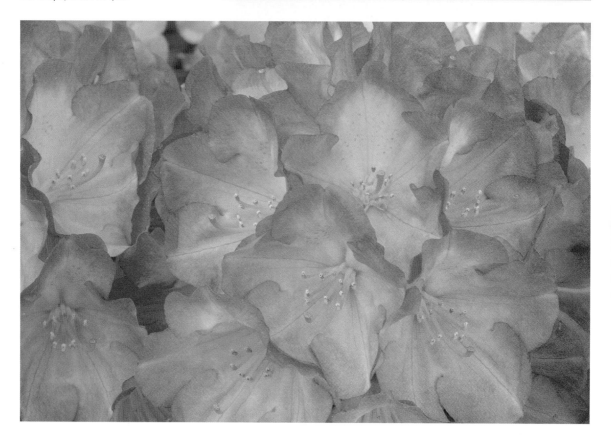

RHODODENDRONS IN SUN

The first of these photographs shows a part of the rhododendron bush which was in partial sunlight. It is a disaster – some flowers are too dark and some too bright.
Nikon D1x with 105mm macro lens, ISO 125, 1/15sec at f/22

RHODODENDRONS IN SHADE

The second photograph was taken further around the bush where there was complete shade, and the result is much better, with even lighting and tone on all the flowers. The cool cast caused by photographing in shade on a sunny day was compensated for afterwards in Photoshop (see Chapter 10).
Nikon D1x with 105mm macro lens, ISO 125, 1/8sec at f/22

Reflectors and diffusers

It is possible to alleviate unwanted contrast in flower photos on a bright sunny day by using a reflector or a diffuser. Purpose made reflectors can be bought from companies such as Lastolite – these come in a variety of colour combinations, with the main three types being white, silver or gold. White will provide the most natural effect, while silver will give a brighter reflection and gold a warm reflection. However, a piece of white card, or card covered with crumpled silver foil, will be fine for reflecting light into small areas. You will need to have your camera on a tripod so that you can position the reflector (or else have a friend to do it for you!). Hold the reflector so that it is directing the sunlight back into the shaded parts of the flower, and look through the viewfinder while adjusting the reflector until you find the best position.

Diffusers are made of translucent material and when positioned between the sun and the flower they soften and spread the light, so that there is much less contrast between highlights and shadows in the resulting image.

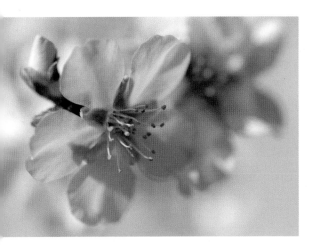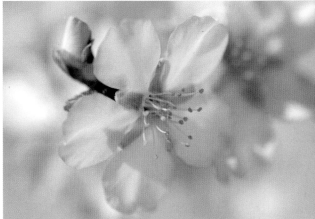

CHERRY BLOSSOM WITH AND WITHOUT REFLECTOR

I would have preferred to photograph these delicate cherry blossoms in bright overcast conditions, but it was a bright sunny day with no cloud in sight. In the first of these photos you can see how there is a dark shadow on the front of the main blossom, and also how the sunlit blossoms behind are brighter than the main subject, and therefore distracting. For the second photo, I used a piece of white card as a reflector to push some light back into the main blossom, making the shadow much weaker, and bringing the flower to the same brightness level as those behind it.
Nikon D1x with 105mm macro lens, ISO 125, 1/2000sec at f/4

HELLEBORE

This hellebore was in patchy sunlight, and in the first photo you can see that this has caused uneven lighting on the flower, with some parts of the petals being too light and other parts too dark. For the second photo I used a diffuser, and this has reduced the contrast, giving an even lighting overall. Because large areas of the image were in shade on a clear day, the colour cast was rather cool and blue, so for the third picture I decreased the blue in Photoshop, giving a more natural, warmer result.

RIGHT **Nikon D2x with 105mm macro lens, ISO 100, 1/45sec at f/9**

BELOW RIGHT **Nikon D2x with 105mm macro lens, ISO 100, 1/20sec at f/9**

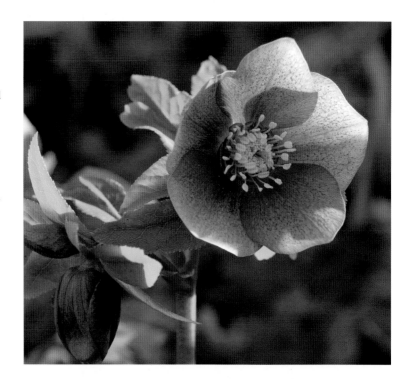

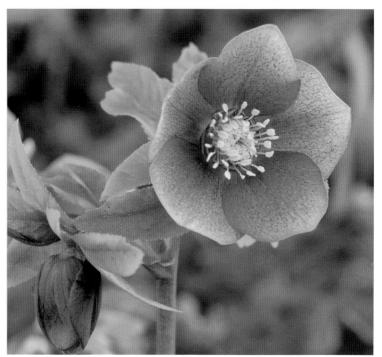

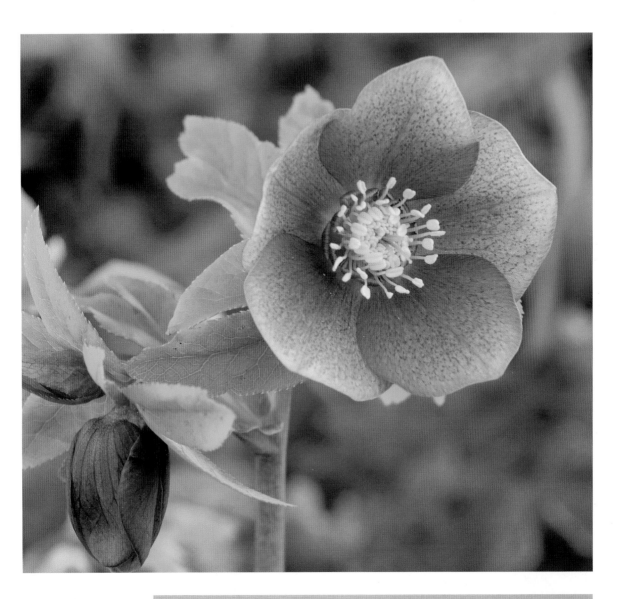

Wind

While on the subject of weather conditions I must mention wind, which is a big factor in outdoor flower photography. There is no doubt that a windless day is ideal, because the photographer doesn't need to worry about blurred pictures resulting from using longer shutter speeds. When conditions are windy, you will have to have a fast enough shutter speed to prevent blur, which means you will have to use a wider aperture (see page 60). This may be a problem if you require a good depth of field in your image.

On a really windy day, it can be fun to experiment and use long shutter speeds to blur the flowers intentionally. You will need to mount the camera on a tripod for this, and set a small aperture so that you can have a long shutter speed. However, there needs to be enough movement in the photo so that it looks intentional and not just a mistake!

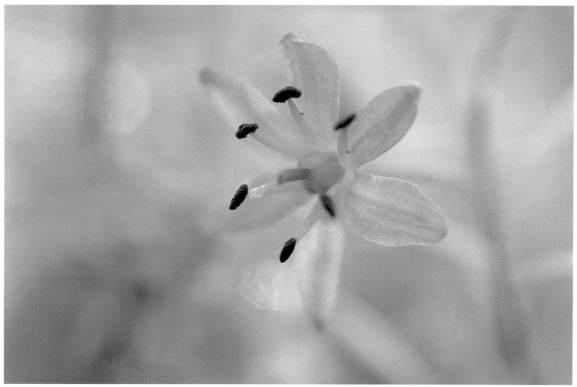

ARGYRANTHEMUM

I photographed this argyranthemum on a bright overcast morning. The gentle light is perfect for enhancing the delicate colours and the raindrops on the petals.

Nikon D1x with 105mm macro lens, ISO 125, 1/1500sec at f/5

SCILLA

The delicate pale blue of these small scilla flowers would have been burnt out if they were in full bright sunlight. Fortunately there was just enough diffused sunlight on this bright overcast day to pick out small highlights on petal edges and stamens, and make the photograph feel light and airy, without any harsh light falling onto the flowers.

Nikon D1x with 105mm macro lens, ISO 125, 1/125sec at f/6.3, exp comp +0.7

Bright overcast

It is often said that the best light for flower photography is bright overcast, which means the type of weather when there is a high, thin layer of cloud which acts as a giant diffuser and softens the sunlight coming through it. This results in much less contrast between light and shadow, and so better detail in all areas of the flower. It also alleviates the problem of one flower casting a shadow onto another one. This light is particularly beneficial for white or light coloured flowers, because their delicate colours won't be burnt out.

Fully overcast

Probably my least favourite weather for flower photography is a day with heavy grey clouds. Many flowers do need the extra lift that the light on a bright overcast day can give to appear at their best. However, all is not lost, even on such days. In these conditions it is still possible to photograph other parts of plants, such as dried seed heads or bark patterns. Alternatively, flowers can be photographed using a touch of fill-in flash.

Warm or cool light

The colour temperature of natural light will vary according to the time of day and the weather conditions. Colour temperature is measured in kelvins, and light with a higher reading on the kelvin scale has a colder, bluer cast, while light with a lower reading has a warmer cast. The important part for a photographer to understand is the effect of different colour temperatures on a photograph. A white flower photographed in warm light will have a warm, red/gold cast, whereas the same flower photographed in cool light will have a bluish cast.

As a rule of thumb, on a day with clear skies the light at the beginning and end of the day is the warmest, and the light at noon is the coolest. An object photographed in open shade on a day with clear blue skies, or on an overcast day, will have a cool blue cast. If you wish, you can compensate for this by adjusting the camera's white balance setting. In general, photographs with a warmer cast are more emotionally appealing to a viewer than those with a cooler cast.

Window light

One of the joys of flower photography is that you can make pictures even when it is pouring with rain outside! A few flowers bought from a florist and a table by a window are all you need for a happy few hours' photography.

If the light coming through the window is quite strong, you may wish to consider using a reflector to put some light back into the parts of the flowers away from the window. Backgrounds can be as simple as a piece of white or coloured card, or as elaborate as you wish with

LILY OF THE VALLEY
This photograph was taken using natural light in a conservatory. The day was bright overcast which was good, because direct sunlight would have caused burnt-out highlights on these delicate white flowers. Because I cropped in close on the flowers there was no need to provide any artificial background, and the result is very natural. A fine mist of water from a plant spray added a touch of freshness to the image.
Nikon D1x with 105mm macro lens, ISO 125, 1/80sec at f/5, exp comp +0.7

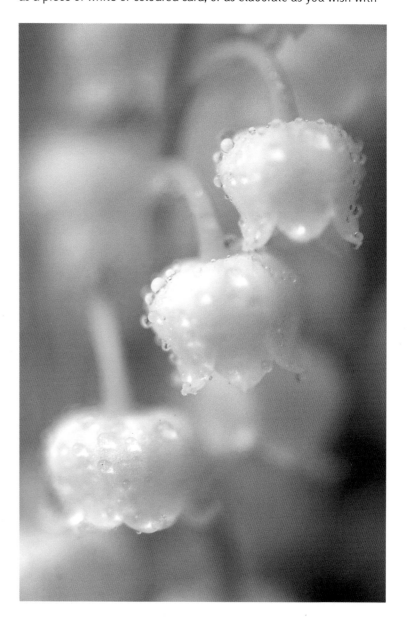

props such as jugs and unusual fabrics or pieces of wood behind your flower. If you fill the frame with the flower itself or even with a part of the flower, so that no background shows at all, then with the natural window light the photo will look like one taken outdoors – without the problems caused by wind!

Studio lighting

With subjects as small as flowers it's not necessary to have a full-size studio lighting set-up. Smaller lighting systems (such as the Bowens TriLite) are available, and these can be ideal for flower photography. The lights are cold lights (unlike tungsten lamps which give off heat and so can cause flowers to wilt), and because they are constant lights rather than flash, the effect of the position of the lights can be evaluated before the picture is taken. Positioning the lights on either side of the flower results in an even, shadowless lighting, and the use of a light tent or 'cocoon', also available from Bowens, increases this effect.

ROSE

I had been asked to produce a photograph of a rose against a light-coloured background, so I used my Bowens TriLites and placed the rose inside a light cocoon, positioning one light at each side. This has produced a very even, shadowless light on the flower and its background.

Nikon D1x with 105mm macro lens, ISO 125, 1/90sec at f/10

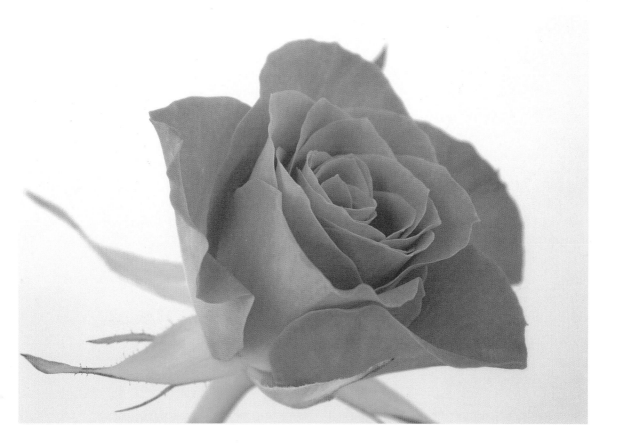

7 Colour

VARIETY

COLOUR THEORY

EMOTIONAL IMPACT

DELPHINIUM BUD

This delphinium bud is less than an inch in length, but within its petals is a spectrum of blues, pinks and purples as well as a little green. I photographed it against an out of focus background of open delphinium flowers so that the same blues and purples in the bud would be repeated behind it.
Nikon D1x with 105mm macro lens, ISO 125, 1/125sec at f/9

Variety

The natural world offers a marvellous and seemingly infinite spectrum of colours, with more varieties of tone and hue than we are able to describe with words. Flowers are no exception, with an astonishing variety of delicate or vibrant colours and subtle gradations of colour even within one small petal. Soft, delicate and pastel, or bright, saturated and intense, the colours of flowers are an artist's palette for the flower photographer.

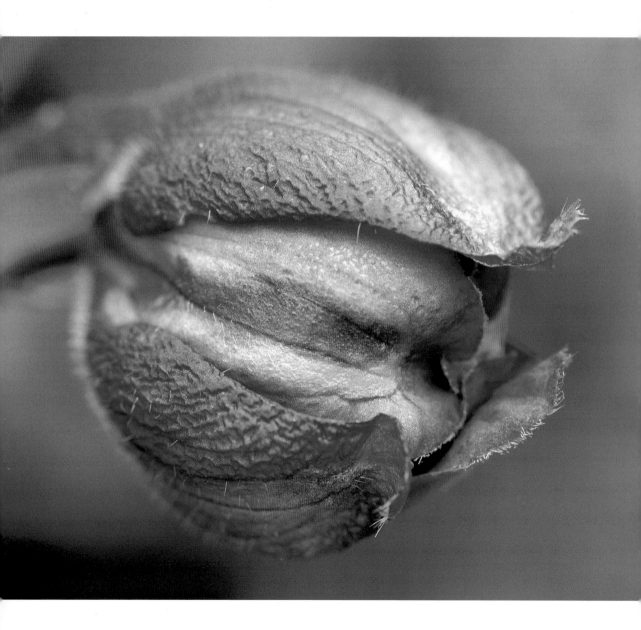

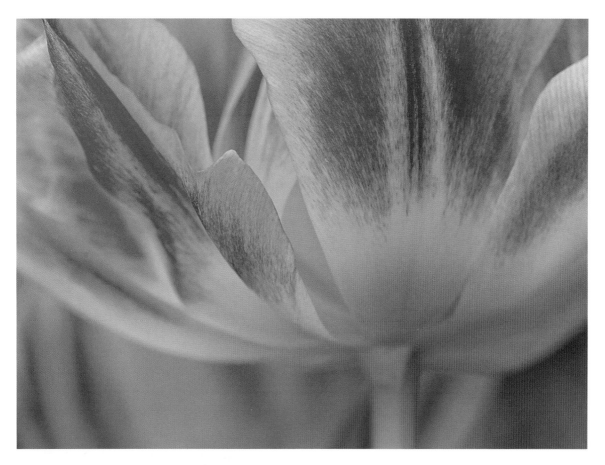

The effect of a colour in a photograph depends not just on the colour itself, but also on whether it is a pastel or vibrant shade of that colour. Both these images consist of pink, yellow and green, but the delicate pastel shades in the photo of the winter hazel make a much gentler image than the saturated colours in the tulip photograph.

PINK AND YELLOW TULIPS ABOVE
**Nikon D1x with 105mm macro lens,
ISO 125, 1/30sec at f/8, exp comp +0.7**

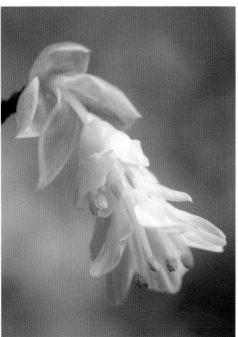

WINTER HAZEL LEFT
**Nikon D1x with 105mm macro lens,
ISO 125, 1/40sec at f/18**

Colour theory

Although you may well respond intuitively to colours and the way they behave within an image, it is useful to have a basic understanding of colour theory and the way colours interact with each other in order to make the best possible use of them in your photograph. Traditionally, colour theory has been based on the colour wheel, in which the three primary colours (blue, red and yellow) are at three points of the circle, and between each pair of primary colours is the secondary colour produced by mixing the two (that is, orange between red and yellow, green between yellow and blue, and violet between blue and red). Between these six colours are many more, as the shades blend gradually from one colour to another.

The colours close to each other on the circle harmonize with each other. Each colour on the circle is opposite its complementary colour (red opposite green, blue opposite orange, and yellow opposite violet), and these complementary colours contrast with each other. So, for instance, if you want to make a punchy, contrasty image of a red flower, position it against a green background; positioning the red flower against an orange background will lessen the impact of the red.

COLOUR WHEEL
Use this to combine colours effectively.

PINK FLOWER
The pink petals of this flower harmonize with the violet tones behind it. The only small patch of colour contrast is provided by the yellow stamens of the flower just visible through the petals.
Nikon D1x with 105mm macro lens, ISO 125, 1/1000sec at f/4.5

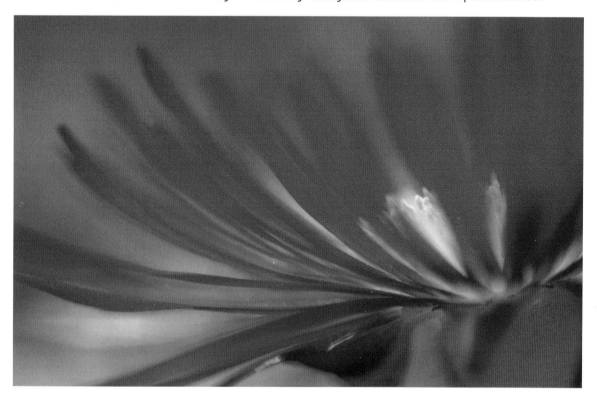

ECHEVERIA SETOSA

The warm reds and oranges of these echeveria setosa flowers contrast well against a green background, since green is the complementary colour to red.
Nikon D1x with 105mm macro lens, ISO 125, 1/40sec at f/13

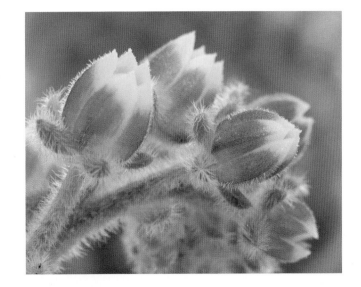

CROCUS

Colour contrast can occur not just between the colour of a flower and its background, but also within the flower itself. The bright yellow stamens of this crocus contrast beautifully with the blue/purple petals, purple being the complementary colour to yellow on the colour wheel.
Nikon D1x with 105mm macro lens, ISO 125, 1/320sec at f/4.2

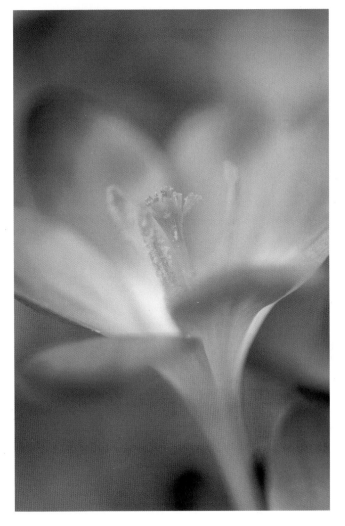

DELPHINIUM AND RED TULIP

Both these photos are abstract close-ups of petals, but the colours in the images give them a very different feel. The blues and violets of the delphinium are next to each other on the colour circle and so are harmonious. Being from the cool part of the colour spectrum, they are also gentle and restful colours.

The reds, oranges and yellows in the photograph of tulip petals are also harmonious with each other, but being from the warm part of the colour spectrum they are much punchier and more assertive than the cool blues of the delphinium.

RIGHT **Delphinium: Nikon D1x with 105mm macro lens, ISO 125, 1/50sec at f/20**

BELOW RIGHT **Red Tulip: Nikon D1x with 105mm macro lens, ISO 125, 1/750sec at f/4**

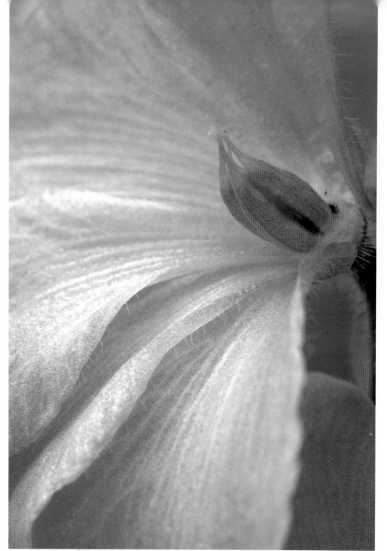

Blues and greens together make a very restful combination, because they are close to each other on the colour circle and therefore harmonize, and also because they are cool, receding colours. It is one of my favourite colour combinations and so one of the reasons I particularly enjoy photographing bluebell woods in spring! I especially like beech woods for bluebell photography, as the new green of the beech leaves is so fresh.

Nikon D1x with 80-400mm lens at 80mm, ISO 125, 1/25sec at f/9, exp comp +0.7

The other important aspect to note about the colour circle is that the reds and oranges are warm, dominant colours, and the blues and greens are cool, receding colours. In practice this means that just a small amount of red, orange or bright yellow in an image will grab the viewer's attention much more than the equivalent amount of blue or green. This can be particularly important in relation to backgrounds (see Chapter Eight) – a small, out of focus red flower in the background to a flower of a cooler hue will drag attention away from the main subject of the photograph. A small amount of blue or green behind a red flower, however, will not usually be a problem.

Interestingly, although a red flower on a green background will make an image with impact, a green flower or leaf against a red background feels uncomfortable. This is because the subject is a receding colour and the background is a dominant one, so a visual conflict has been created.

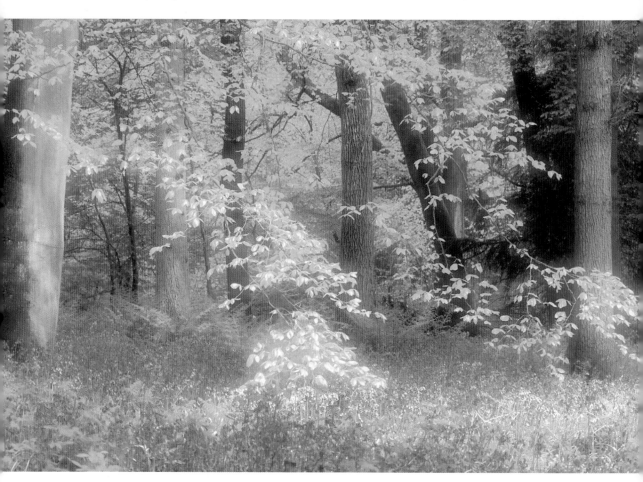

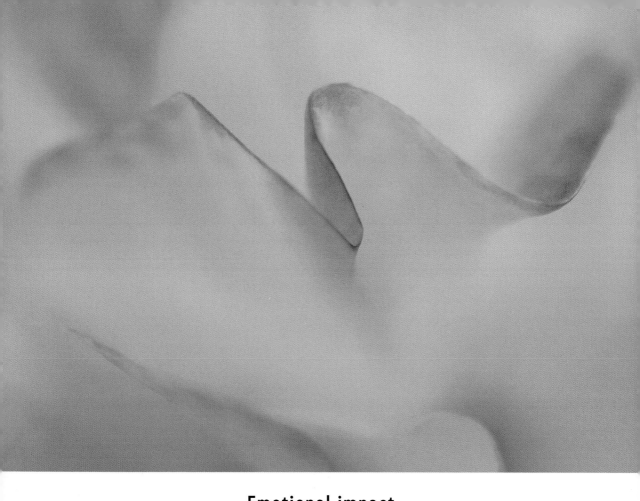

Emotional impact

Colours have an emotional impact on the viewer, and are often said to have a language of their own. Reds and oranges are powerful, joyful and energizing, and create a positive response in the viewer. You only have to look at the way warm colours are used to manipulate our emotional responses in advertising to appreciate this – a product will be presented in a warm, fuzzy glow to make it seem desirable. Yellows are uplifting and stimulating, greens are restful and safe, blues are tranquil and calm. It is an interesting exercise to discover which colours tend to appeal to you, in photographs or paintings. Do you generally prefer warm or cool colours? Subtle shades or vibrant hues? A limited colour palette or a riot of different colours? Harmonizing colours or contrasting ones? This may not seem directly relevant to the practical business of taking a photograph of a flower, but fine-tuning your awareness of colour and how it works can only be of benefit as you evaluate the way the colours are working when you make an image.

PINK AND YELLOW ROSE

I always enjoy images with a limited colour palette, and one of my favourite colour combinations is yellow and pink. When I found this wonderful rose with yellow and pink petals, I decided to go in very close and make an abstract image with only the pink edges of the petals sharp against the deeper golds of the centre of the flower.

Nikon D1x with 105mm macro lens, ISO 125, 1/1250sec at f/5

WINDOW WITH HIBISCUS

The colour red has positive, happy connotations. When I look at this photograph of red hibiscus flowers growing over a window with red shutters I can almost feel the warmth of the Mediterranean sun!

Nikon D1x with 28-105mm lens at 50mm, ISO 125, 1/160sec at f/6.3

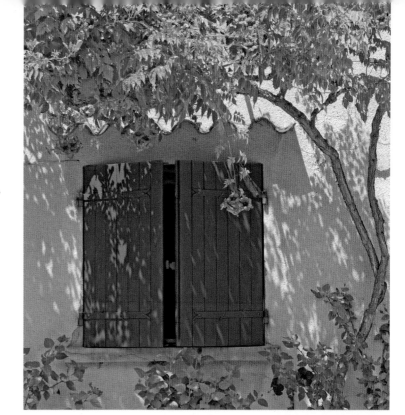

No rules

There are no rules about what you should and shouldn't do with colour in a photograph, and the decisions about whether the colours in your viewfinder work well and make a balanced composition is in the end an intuitive one. However, as in other aspects of composition, less is sometimes more, and it can be much more effective to have only one or two beautifully harmonizing or contrasting colours in your photograph than a host of random and unrelated shades.

TULIP ABSTRACT

Colour can sometimes become the subject of your photograph, rather than the flower itself. I was so taken by the glorious colours of the base of this tulip that I cropped in close and made an image that was more about the wonderful golds, pinks and reds than about a flower.

Nikon D1x with 105mm macro lens, ISO 125, 1/250sec at f/9

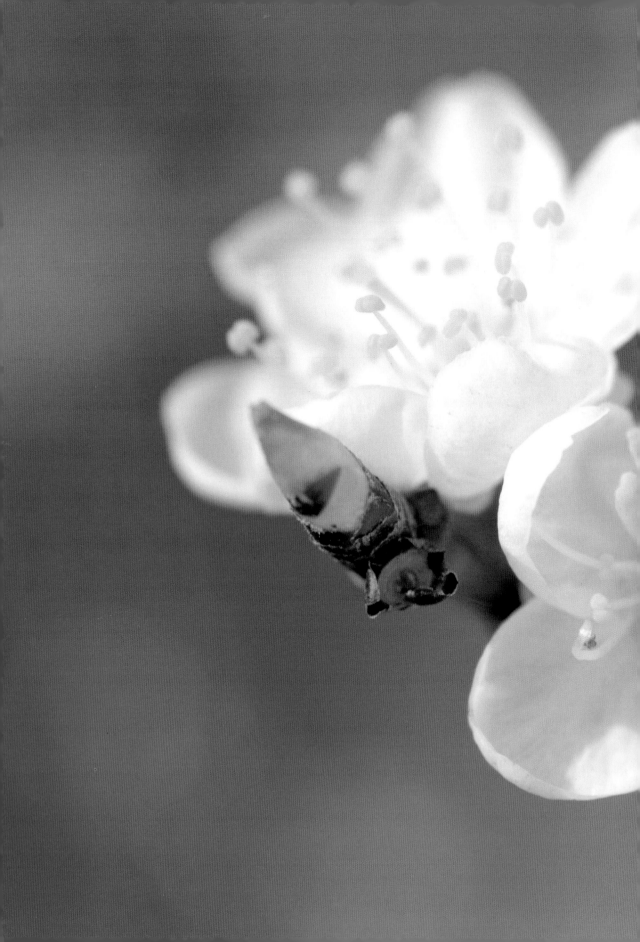

8 Backgrounds

Looking around

The importance of backgrounds in flower photography cannot be over emphasized – in many ways the background is just as vital to the success of the image as the subject of the photograph. Of course, if you are photographing a flower at such a close focusing distance that the flower fills the whole frame, then there will not be a background; but in every other portrait of a flower, there will be a background of some sort. If this background is messy or distracting in any way, then the photograph will not be a successful one, no matter how beautiful the subject flower may be.

I mentioned when discussing contrasty light how much more objectively the camera sees than the human brain and eye, and this fact also applies very much to backgrounds. If you look at a lovely

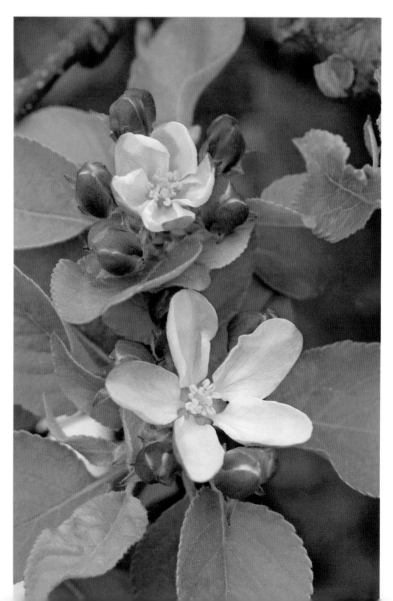

rose through your viewfinder, your attention will be on the flower itself, and it is the easiest thing in the world not to notice a torn leaf or broken twig behind the flower – but this will be recorded by the camera just as faithfully as the rose itself, and in the resulting image it will be a distraction. So a large part of the battle for a good background can be won just by training yourself to look all around the edges of your frame and at all the areas visible behind your subject before you press the shutter release. As well as unsightly twigs or leaves, look out for other blooms which may distract attention from the main subject, especially if they are a bright or more dominant colour. Even a patch of light reflecting from a shiny leaf can distract the viewer's eye from the subject. Worst of all are bamboo poles, plastic plant supports or labels proclaiming the plant's species!

APPLE BLOSSOM WITH AND WITHOUT SIGN
It is surprisingly easy to miss something distracting in the background of your picture because you are concentrating so much on the subject. I had taken a couple of photos of this apple blossom before I noticed the white sign behind the leaves at bottom left. I carefully removed it and took another photograph, replacing the sign afterwards.

LEFT **Nikon D1x with 105mm macro lens, ISO 125, 1/80sec at f/7.1**

RIGHT **Nikon D1x with 105mm macro lens, ISO 125, 1/60sec at f/9**

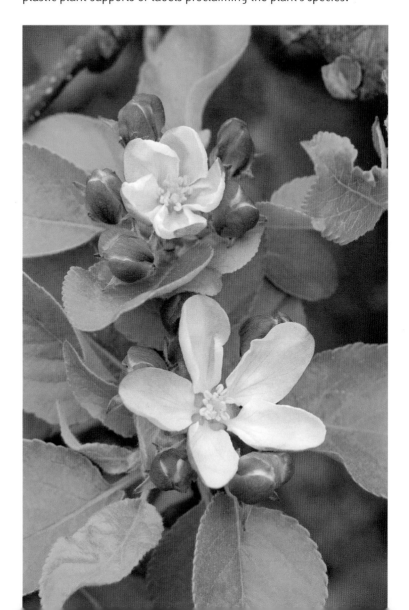

Once you have become aware of another flower or some foliage which is distracting behind your main flower, you may be able to deal with it by carefully bending a stem and tucking it out of sight. In my own garden I would cut off an offending leaf, but would never do this in someone else's garden. If this does not work, very often a small change of viewpoint will do the trick – by moving a little to the left or right you may be able either to hide the distracting object behind something else or exclude it from the image completely.

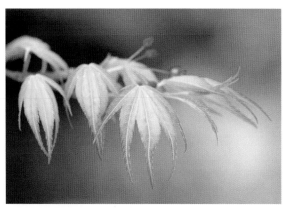

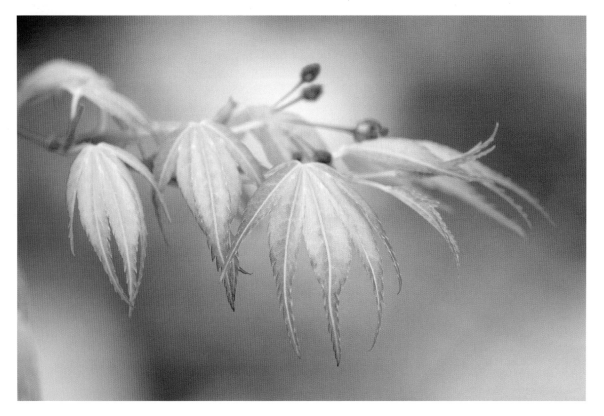

ACER LEAVES LEFT

A very small change in your position can make a big difference to the resulting image. These acer leaves were growing in front of a small stream, which looked white as it reflected the light, with green mossy rocks in the water. I used an aperture of f/8 to keep as much of the leaves sharp as possible while still throwing the background out of focus. In this set of three photographs you can see how each tiny shift in my position has put the leaves in front of backdrops with different distributions of green and white areas, giving a very different feel in the resulting images. My favourite of the three is the last one, as I feel the position of the light areas sets off the leaves to best advantage.

Nikon D1x with 105mm macro lens, ISO 125, 1/80sec at f/8

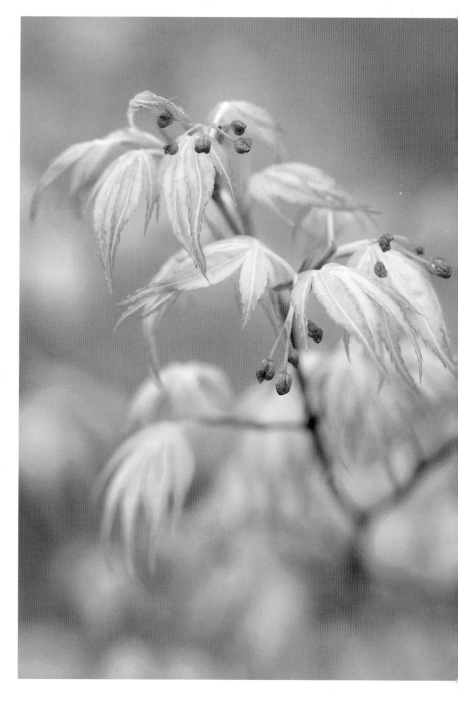

ACER LEAVES ABOVE

I then changed my viewpoint and photographed some of the leaves against a backdrop of other leaves on the same tree, which resulted in an image with a completely different feel. An aperture of f/5 has given a shallow depth of field, and I love the impressionistic effect of the out of focus leaves in the background.

Nikon D1x with 105mm macro lens, ISO 125, 1/250sec at f/5

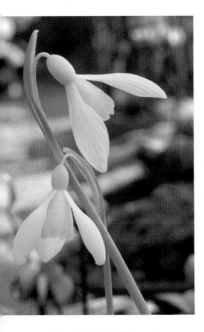

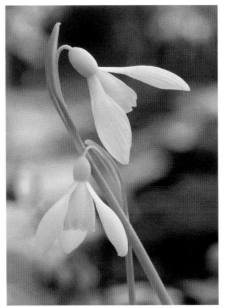

Nikon D1x with 105mm macro
lens, ISO 125, 1/15sec at f/25

Nikon D1x with 105mm macro
lens, ISO 125, 1/80sec at f/11

Nikon D1x with 105mm macro
lens, ISO 125, 1/800sec at f/3.3

SNOWDROP

I found this lovely and rather unusual
snowdrop growing in a pot in a greenhouse.
It was impossible to find a position to shoot
from where the background was clear of
other plants and pots and the sand in
between them all. This set of three pictures
was taken with the camera on a tripod, and
the only thing which was changed between
each exposure was the aperture setting.
You can clearly see what a dramatic effect
this has had on the resulting image. At f/25
all the clutter in the background completely
ruins the picture. At f/11 the details of the
clutter have been softened, but it is still
very distracting. In the final photograph,
taken at f/3.3, the background has become
an abstract wash of colours, and no longer
competes with the snowdrop for the
viewer's attention.

Adjusting the aperture

Other than physically moving either yourself or bits of plant, your
main control over the way the background appears in your photograph
will be by adjusting your aperture to obtain the most suitable depth of
field for the image (see page 60). Very often a background of foliage
that would be very distracting if it was in sharp focus at f/16 can
become a gentle wash of harmonious colour at f/4. I don't regard this
technique as just controlling a negative thing – getting rid of a bad
background – but actually introducing a positive thing into the image
– a beautiful out of focus wash of colour behind your subject.

PLUM BLOSSOM AND SPIRAEA OPPOSITE

Because I photographed this plum blossom (right) against the blue sky, I could use
a small aperture to have plenty of sharpness in the flowers without worrying about
distracting elements being sharp in the background. However, I personally find the
plain blue backdrop rather uninteresting compared to the gentle backdrop of soft
whites and greens in this photograph of tiny spiraea flowers (far right).

PLUM **Nikon D1x with 105mm macro lens, ISO 125, 1/100sec at f/18**

SPIREA **Nikon D1x with 105mm macro lens, ISO 125, 1/125sec at f/5, exp comp +0.7**

BLUEBELLS

I always enjoy photographing a flower against a backdrop of other flowers of the same colour, and using a wide aperture to throw the background flowers right out of focus. In this photograph I focused on one bluebell flower at an aperture of f/4.8, which meant that the other bluebells behind it became a gentle blue backdrop. The subject flower was isolated from the background both by the light falling on it and by the differential focus.

Nikon D1x with 105mm macro lens, ISO 125, 1/160sec at f/4.8

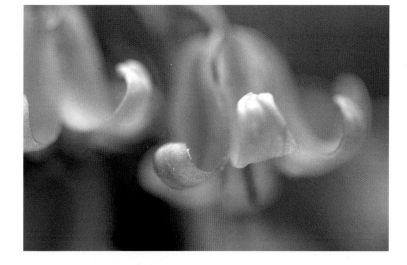

RANUNCULUS

As well as throwing a background completely out of focus, selective focusing at a wide aperture can be used to have one subject flower sharp, and others behind it less sharp and more impressionistic. To photograph these delicate ranunculus flowers I selected an aperture of f/3.3, and focused on the centre of the front flower, allowing the flower and buds behind to go out of focus. The background flower is much softer and so is not competing with the subject flower.

Nikon D1x with 105mm macro lens, ISO 125, 1/250sec at f/3.3

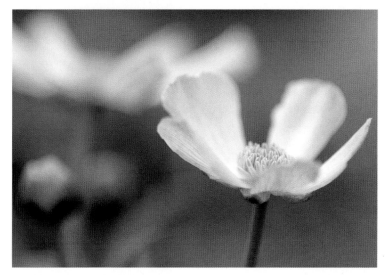

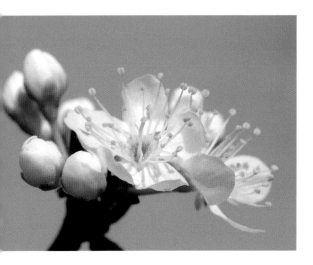

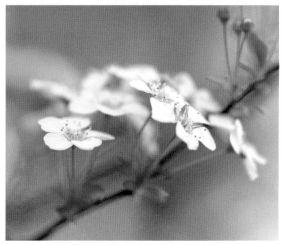

Choice of lens

The amount of background that is included in your image is determined not only by the size of your subject and your distance from it, but also by your choice of lens. As explained in Chapter Two, a wide-angle lens will give you a much wider view than a standard or telephoto lens. If you stand close to a plant and photograph it with a standard lens, you will include a wider area of background in your image than if you stand further away and use a telephoto lens. A wide-angle lens can be useful for a portrait of flowers in their environment, as in the picture of Swiss wildflowers on page 24;

PEAR BLOSSOM

I photographed this branch of pear blossom against a backdrop of grass, which provided a nice plain non-competing background for the flowers. However, I prefer the effect of the background in the photograph of crabapple blossom (opposite), where the flowers were photographed against a backdrop of other similar flowers – this has given a more delicate and interesting background than the uniform green of the grass.

Nikon D1x with 105mm macro lens, ISO 125, 1/320sec at f/6.3

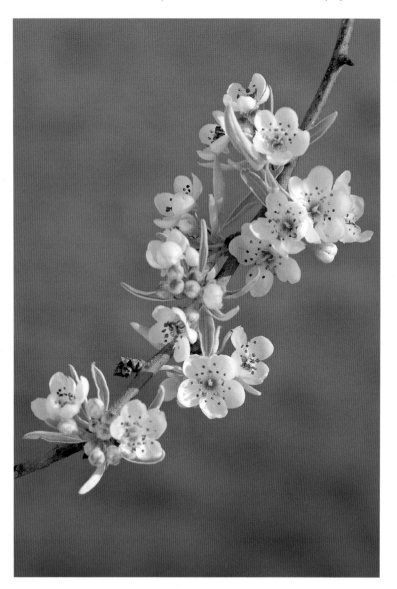

but if you want to create an out of focus background in the way just described, you will ideally need to use either a telephoto or a macro lens. Be aware of the colour of your background, and how it interacts with the colour of your subject flower. As discussed in Chapter Seven, colours can be harmonious or contrasting, and can also be dominant or receding. I find that if a flower with a cool, receding colour is photographed against a background with a dominant colour, the balance of the image feels wrong. Also, remember that out of focus patches of dominant colours in the background will compete for attention with the main subject even if they are small.

CRABAPPLE BLOSSOM
Here the flowers are photographed against a backdrop of similar flowers.
Nikon D1x with 105mm macro lens, ISO 125, 1/640sec at f/5

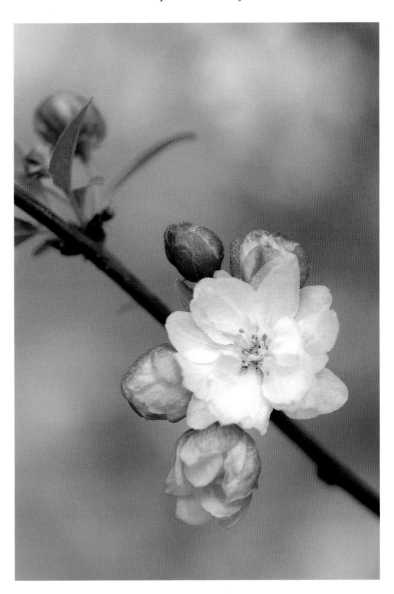

CALLA LILY
Nikon D2x with 105mm macro lens,
ISO 100, 1/3sec at f/16

Studio backgrounds

If you photograph flowers indoors, either by window light or with studio lights, you have complete control over the background to your photograph. This has both advantages and disadvantages – you won't have to contend with unwanted distracting elements behind your flower, but on the other hand you won't have the benefit of large areas of harmonious flowers or foliage behind your main subject which you can throw out of focus, as in the photo of crabapple blossom on the previous page.

One of the main considerations when choosing your background is what colour to use. As discussed in Chapter Seven, colours close to each other on the colour wheel are harmonious, whereas colours opposite each other will contrast. Your decision whether to use a harmonious or contrasting colour will greatly affect the feel of the image. In this series of photos of a calla lily, all three backgrounds are obviously artificial, but nevertheless the results are quite different.

The yellow background and the pink background are both harmonious with the subject, as they echo the colours in the flower; but the effect of the yellow is gentler than the pink because it is a less saturated colour. The blue background contrasts with the flower instead of harmonizing with it, and the result is much more punchy. None of the colours is necessarily right or wrong – your choice depends on the effect you are seeking to achieve in your image.

Don't feel that you have to buy purpose made backgrounds for your indoor flower photography – I tend to use whatever comes to hand. In the three photos opposite, all the backgrounds came from my wardrobe – the yellow background was a chiffon scarf, and the pink and blue backgrounds were both hoodies!

ROSE WITH WATER DROPS
A piece of white card can make a backdrop to almost any flower. In this photograph the simple white backdrop and the water droplets combine to make a fresh, light image.
Nikon D1x with 105mm macro lens, ISO 125, 1/350sec at f/5

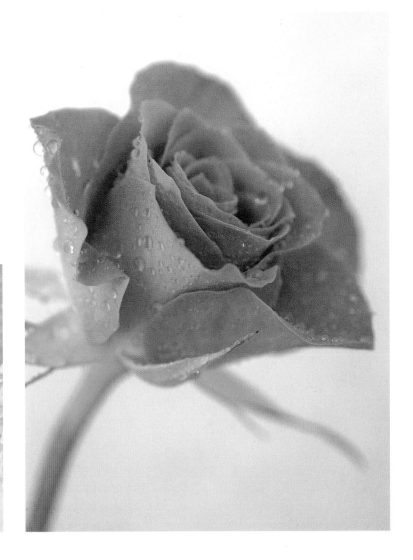

Pro Tip

One way of making a more natural looking background is to photograph some grass or foliage completely out of focus so that it is a gentle wash of greens, make a large print of it on matte paper, and put that behind your flower – you just need to take care to avoid the light reflecting on it. I used this type of background for the orchid photograph on page 45.

9 Composition

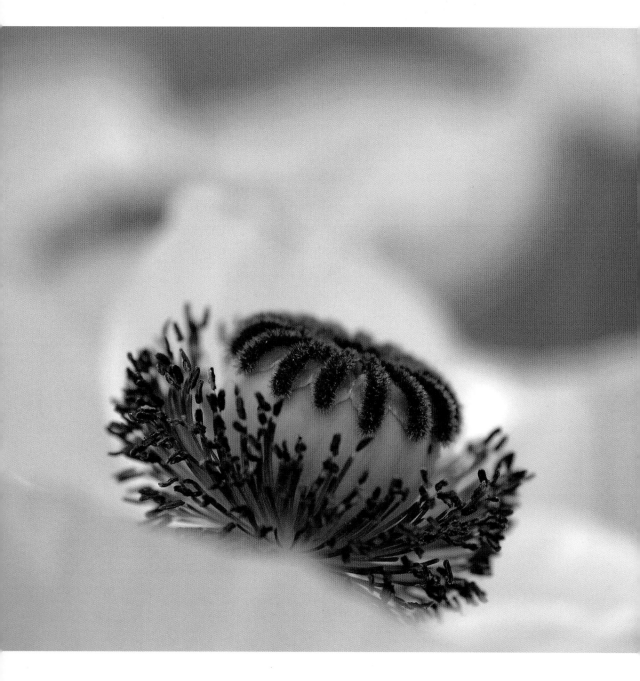

PINK POPPY

My focal point in this photograph of a pink poppy was its gorgeous magenta
and green centre, and I emphasized this by using an aperture of f/5 so the
centre was sharp while the petals around it were soft. Placing the focal point
on one of the rule of thirds intersection points has made a more dynamic
composition than would have been the case had it been centrally positioned.
Nikon D1x with 105mm macro lens, ISO 125,
1/500sec at f/5, exp comp +0.7

Asking the right questions

Finding a good composition is one of the most enjoyable as well as one of the most challenging aspects of photography. But what are the elements that make a good composition? All of the factors that we have looked at so far – light, colour, subject, background, depth of field – need to be considered when evaluating the composition of a photograph.

Any photograph is a selection from the scene in front of the photographer – even a wide, sweeping landscape image is only a part of the view seen and must be selected and framed. A flower is only a tiny part of the whole scene, but even once that flower has been chosen from all the other elements around it, there are still many choices to be made in deciding how to photograph it. Should it be small in the frame, with the details of its natural environment surrounding it, or should it be isolated against an out of focus backdrop? How is the natural light affecting both the subject and its background? How do the colours within the frame relate with each other? Which of the elements on offer should be included in the photograph and which should be left out?

In this chapter I will look at various compositional rules which can be of help, but these can only ever be general guidelines, and the decision about whether or not to follow them has to be made by the photographer in relation to each individual photograph. In the final analysis, a decision about composition is an intuitive assessment of the balance of light, colour and shape within the image. You can fine-tune your awareness of balance within a composition with continual practice and observation, not just of the subjects you are photographing, but of other photographers' work, and indeed artistic work in any visual medium.

When you look at a photograph or painting, you will know instinctively whether you like the composition or not, so try to analyse why it is that you like or dislike it. When you have taken two different photographs of the same subject which are both properly exposed and focused, and you prefer one shot to the other, try to define what it is about your preferred image that makes it better. The more you can fine-tune your vision in this way, the more instinctively you will arrive at a good composition in your images.

It definitely helps when taking photographs if you are completely familiar with your equipment, so that you can concentrate your mind on composing your image without being distracted by worries about technical issues. Also, I find it almost impossible to make a really satisfying image if I am rushed for time or worrying about something else that I should be doing. The more you can focus your mind and become totally absorbed in what you are seeing through your viewfinder, the easier it will be to achieve an image where all the elements are in harmony and the composition really works.

The Rule of Thirds

Probably the best known of the compositional rules is the rule of thirds, or golden rule, which has been used for centuries by painters. This says that a picture will be more interesting if the subject is not bang in the middle of the frame, but positioned off-centre. Imagine a noughts-and-crosses grid across your image – the strongest or most interesting position for your subject will be on one of the points where the lines intersect, or else running along one of the lines.

In a landscape photograph, it is usually more interesting visually for the horizon to be on one of the two horizontal grid lines (either one third from the top or one third from the bottom of the frame) than across the centre of the frame, cutting the image in half.

In a close-up photograph, if your centre of focus is, say, a pink flower surrounded by green foliage, the chances are the composition will be more interesting and dynamic if the flower is on one of the intersection points rather than in the centre of the frame. But there is an exception to every rule, and the rule of thirds should not be followed slavishly. If you feel the composition works best in a different way, then that is the way you should make the image.

SUNFLOWERS AND CLOUDS
The first of these photographs of a field of sunflowers is compositionally static and boring. The division between the flowers and the sky is more or less half way up the frame, and there is no particular focal point. For the second photograph I chose one of the sunflowers which was slightly taller than those around it and went closer to it so that it was larger in the image, positioning it approximately on one of the rule of thirds intersection points. This has made a much more dynamic composition, and has had the effect both of making one of the flowers a definite focal point, and of breaking up the half and half division between flowers and sky.

TOP **Nikon D1x with 28-105mm lens at 32mm, ISO 125, 1/15sec at f/22, polarizer**

BOTTOM **Nikon D1x with 28-105mm lens at 48mm, ISO 125, 1/30sec at f/18, polarizer**

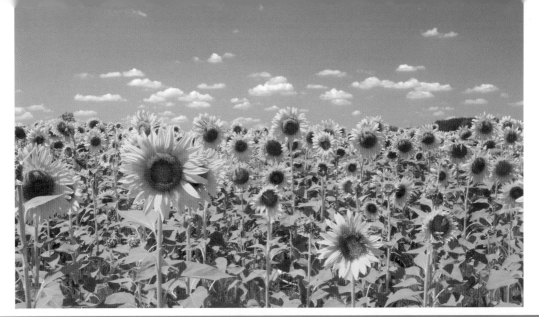

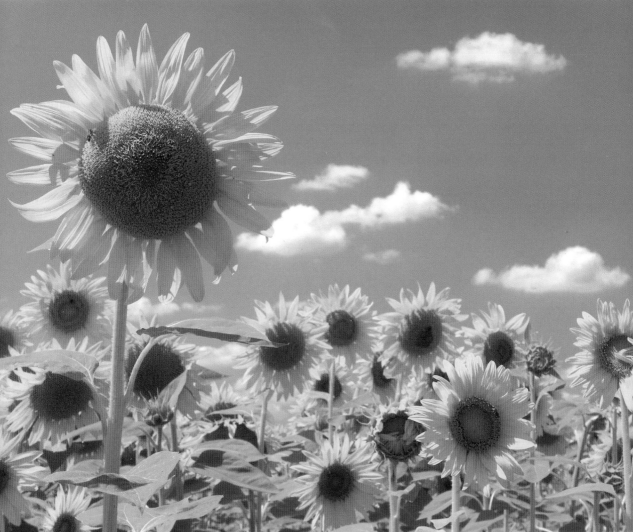

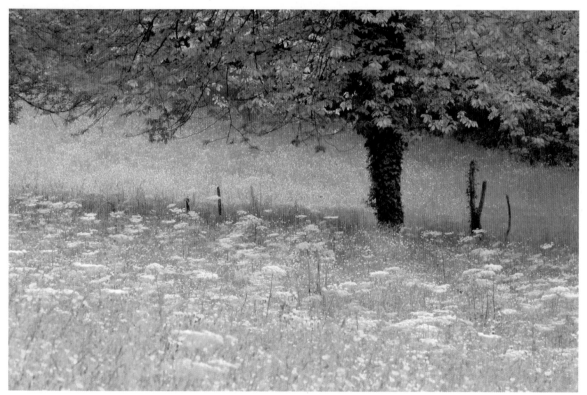

TREE AND WILDFLOWERS

It can be interesting to make a series of images of a scene and then evaluate which of the different compositions of the same subject is most successful. In the first of these images I placed the tree in the top third of the frame, but its trunk was centrally positioned within that third. In the second picture I turned the camera slightly to the left, so that the tree trunk was closer to one of the intersection points according to the rule of thirds.

This makes the second image more interesting and less static visually than the first. I then turned the camera to a horizontal orientation, again with the tree trunk positioned on one of the rule of thirds intersection points, and I think this is the most satisfying of the compositions, emphasizing the wide spread of the branches above the corresponding sweep of wildflowers.
Nikon D1x with 80-400mm lens at 270mm (TOP TWO PICTURES) and 230mm (BOTTOM PICTURE), ISO 125, 1/10sec at f/22

Diagonal lines

An image containing horizontal or vertical lines is more static than one with diagonal lines, which are visually more dynamic. I found this line of sunflowers growing among pale grasses, and was attracted by the colours, but found it quite difficult to make a successful composition. The first image here is static and visually uninteresting because the line of sunflowers is more or less vertical and running up through the middle of the frame. In addition to this there is no focal point in the picture. The second photograph works better, because the line of yellow flowers is now diagonal which is more stimulating visually, and also the front sunflower, being much larger and sharper than those behind it, is a definite focal point.

SUNFLOWERS AND GRASS

The near vertical line of flowers below is less effective than the diagonal line in the picture on the right.

BELOW **Nikon D1x with 105mm macro lens, ISO 125, 1/320sec at f/9**

RIGHT **Nikon D1x with 105mm macro lens, ISO 125, 1/2000sec at f/3**

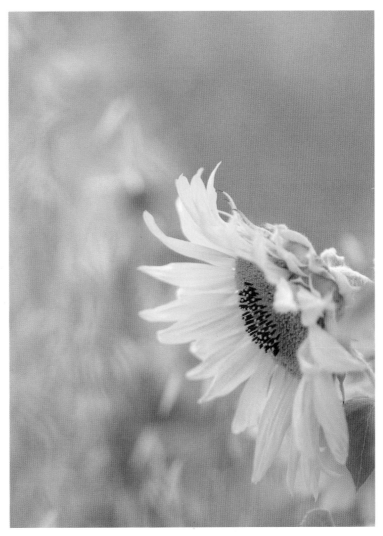

Simplicity

In my view, simplicity is the key to successful composition. The strongest photographs are almost always those where there is one definite point of interest, and the rest of the image is playing a supporting role to this focal point. If there are several different and unrelated elements in the photograph, it can be unsatisfying because the viewer's eye doesn't know where in the image to rest. Imagine listening to a flautist playing one tune at the same time as a pianist playing a different one. They may both be playing beautifully, but you can't enjoy either of them because they are each distracting from the other, and your concentration cannot settle. If the flautist played his tune and the pianist played a supporting accompaniment, the tension between the two elements would turn into harmony. In the same way, you need to achieve a visual harmony between the various elements in your photograph.

POPPY AND BUD

I love oriental poppies and my eye was caught by this gorgeous dark coral variety. The first photograph is a record of the poppies, but doesn't really say anything about them or about what it was that attracted me to them. I analysed what it was that I was drawn to, and decided it was the beautiful colour of the petals, and also the way the petals emerging from the bud looked like crumpled silk. For the second image I zoomed in closer with my telephoto lens and cropped out all the distracting elements – leaves, unopened buds and so on – so that the focal point of the photograph became one of the emerging buds, supported by the gorgeous coloured petals of the flower behind it. The open flower was thrown just enough out of focus so that it wouldn't compete with the bud for attention, while still clearly being an open poppy and so giving supporting information to the poppy bud.

LEFT **Nikon D1x with 80-400mm lens at 220mm, ISO 125, 1/40sec at f/11**

BELOW **Nikon D1x with 80-400mm lens at 400mm, ISO 125, 1/40sec at f/11**

One of the best ways to approach this is to take a few moments to evaluate your subject before you take your camera out of the bag and start photographing. Ask yourself what it is that interests you or attracts you in the scene or the flower you are looking at. Having identified what it is you want to emphasize in your image, evaluate the other elements around it and ask yourself whether they support your main subject or distract from it. If they distract, then decide whether you will be able to exclude them altogether, or whether you will need to deal with them in some other way, such as by using a shallow depth of field to throw them out of focus.

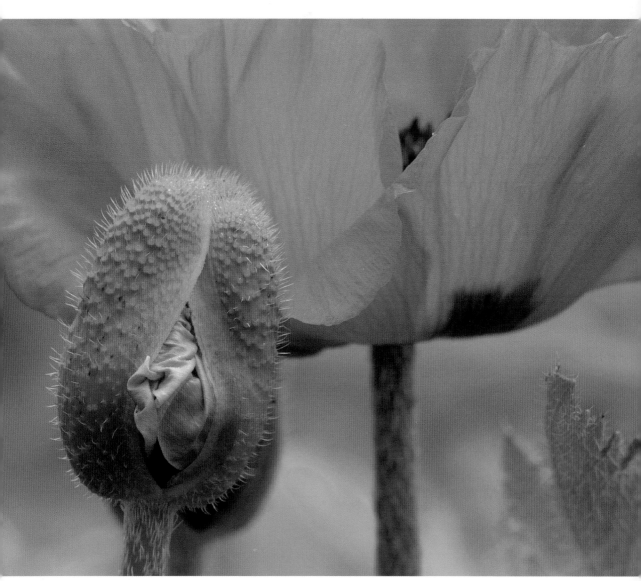

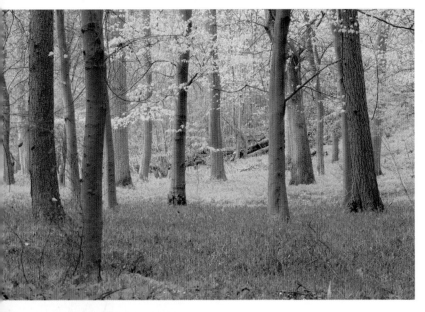

BLUEBELL WOOD

I went to a local wood to photograph bluebells, but although the flowers were lovely, it was difficult to make a clean composition because there were so many bare branches, fallen trees, and other distracting elements. I decided to use a panning technique – I moved the camera vertically during an exposure of 1/10sec – and this has produced a much more abstract image, simplifying it and removing the clutter. Panning is a fun technique to play with, but be prepared to take a lot of photographs to get one which really works!

Nikon D1x with 80-400mm lens at 105mm, ISO 125, 1/10sec at f/18 (LEFT) and f16 (BELOW)

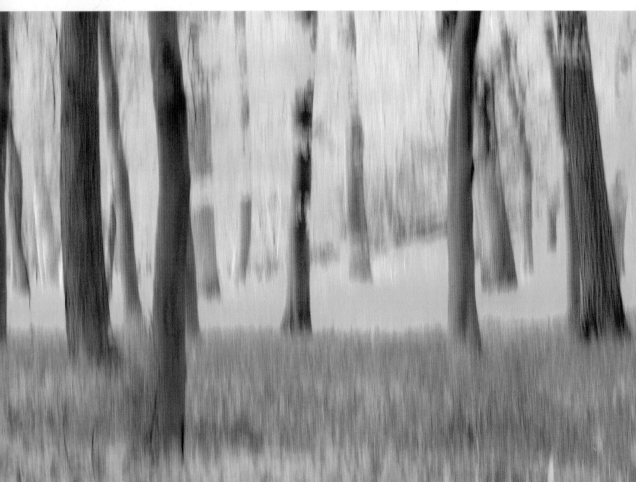

ROSE SPIRAL RIGHT

This rose had a beautiful centre, but the outer petals were rather ragged and spotted. I used my macro lens and filled the frame with the inner petals, excluding the tatty outer petals and leaves. This has simplified the composition and focused attention on the beautiful colours and spiral shapes made by the petals.

Nikon D1x with 105mm macro lens, ISO 125, 1/1000sec at f/5.6

MAGNOLIA BELOW

Although getting in closer is usually better, it is not always the case. In these two magnolia photos, the second image works better, because the curve of the branch leads the viewer's eye round and up to the flower instead of the stalk coming straight up from the bottom of the frame.

Nikon D1x with 105mm macro lens, ISO 125, 1/200sec at f/5.6 (LEFT), 1/250sec at f/4.5 (RIGHT)

Moving in close

Very often the answer to achieving a simple and effective composition is simply to move in closer to your subject. If this means cropping right into a flower so that some of the petal edges are cut off, however, make sure this is definite enough to be obviously intentional – if just the tips of some of the petals are missing, it may look like a mistake!

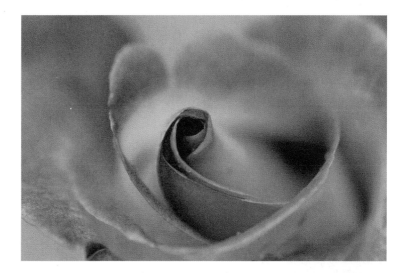

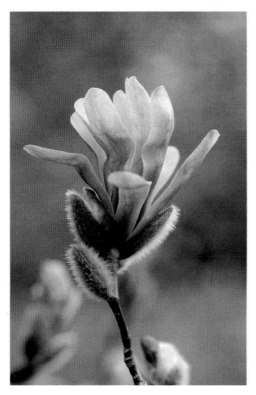

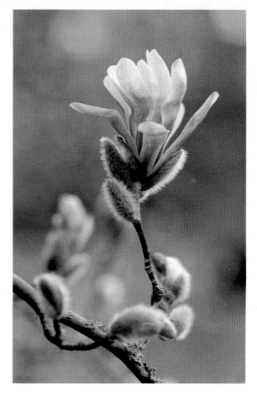

Picture orientation

One of the simplest and yet often overlooked ways to change a composition is to move the camera from a horizontal orientation to a vertical one. I will usually look at my subject both ways, and in most cases it will be obvious that one orientation is better than another – look again at the photos of the tree in a wildflower meadow on page 110. If it is not obvious which works best, then I will take the photograph both horizontally and vertically!

TULIP

I love cropping in tight on tulips and photographing the base of the flowers, since that is often where the most interesting colours occur. I usually find that a horizontal orientation seems to work best for this subject, but in the case of these particular tulips, a vertical orientation worked just as well because of the slight separation of one petal from the rest of the flower, which added interest to the composition. In each case I tried to get the best distribution of supporting out of focus colour in the background.

LEFT **Nikon D1x with 105mm macro lens, ISO 125, 1/1250sec at f/3.5**

BELOW **1/350sec at f/7.1**

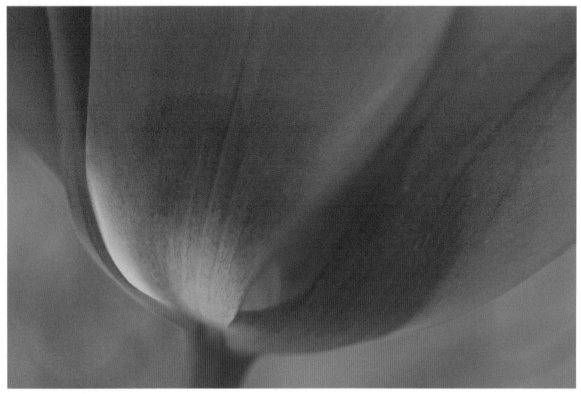

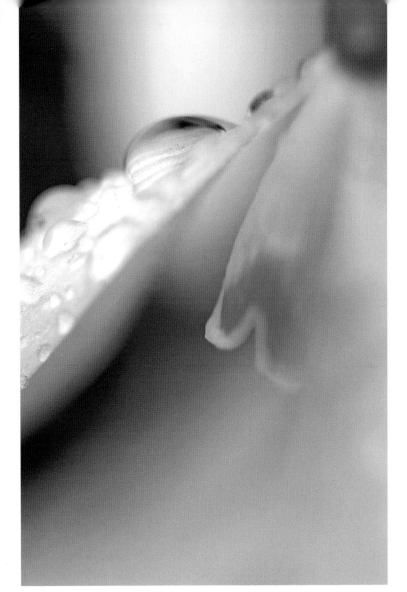

It was raining very lightly as I photographed some snowdrops, and I decided to focus on the drops of water, allowing most of the petals to go softly out of focus. At such a close focusing distance there was no real way to evaluate the composition beforehand, so I just moved around the flowers while looking through my viewfinder until I found the composition I wanted.

Nikon D1x with 105mm macro lens, ISO 125, 1/80sec at f/4.5, exp comp +1

I mentioned evaluating what it is that attracts you in a scene before you start to photograph it, but when I am photographing very close up I adopt a slightly different approach. In this case I set my camera to its closest focusing distance and look through the viewfinder while I work my way around the flower, seeing how the composition changes as I move a fraction to left or right, up or down, towards or away from the flower. At such close focusing distances a tiny movement will make a big difference to the resulting image, and as I move around I am continually evaluating the balance of shape and colour within the frame. One word of warning: it can be very absorbing and you may well find that a lot of time has gone by while you have been immersed in a close-up world!

The emergence every spring of the green shoots of snowdrops and crocuses from the winter earth signals the start of my busiest season as a flower photographer. Although there are many wonderful blooms in summer, spring flowers are always my favourites – partly because they are often more delicate than their summer cousins, and partly because it is just so wonderful to be photographing flowers again after the winter months! Crocuses are always a wonderful subject, whether as a single flower or as a carpet of white, purple and gold.

Because crocuses are low growing plants, any photograph of them taken from standing height or even kneeling height will inevitably include some of the ground in which they are growing, and although this may sometimes be grass, it will very often be just soil. Bare earth is seldom attractive in a photograph, and will make a very dark background for the flowers. I'm afraid the only answer is to get down to ground level so that you are looking straight ahead at the crocuses on their level, and then the background will be other crocuses or grass behind the flowers instead of

CROCUS CLOSE–UP

This crocus had dropped some of its pollen onto its lower petals, so I cropped in close and focused on the tip of the stigma, using a shallow depth of field. This has thrown the dropped pollen out of focus so that it becomes a soft golden shape reflecting the golden stamens above it.

Nikon D1x with 105mm macro lens, ISO 125, 1/125sec at f/5

the earth underneath them. If you are lucky enough to have a right-angled viewfinder or a swivelling LCD monitor with live view, you may be able to escape the fully prone position – but I just have a regular viewfinder, so I have to get right down there. The best piece of additional kit you can take with you is something waterproof to lie on!

The upside of the fact that crocuses are so low-growing is that wind is not generally so much of a problem as it can be with taller plants. This means that the main weather consideration, apart from the light, is rain. If there has been a heavy rainfall you may well find that tiny specks of mud have been splashed up from the flowerbed onto the petals. While not visible to a casual glance, these will certainly be visible if you are photographing a crocus at a close focusing distance with a macro lens. On the other hand, it can be lovely to photograph crocuses after a very light rainfall, as this will not splash mud onto the petals but instead will adorn each flower with tiny water droplets.

As far as light is concerned, I usually prefer a bright overcast light, as bright sunlight can cause hard shadows and burnt-out highlights. If I do photograph crocuses in bright sun, I try to position myself so that the sun is backlighting the flowers.

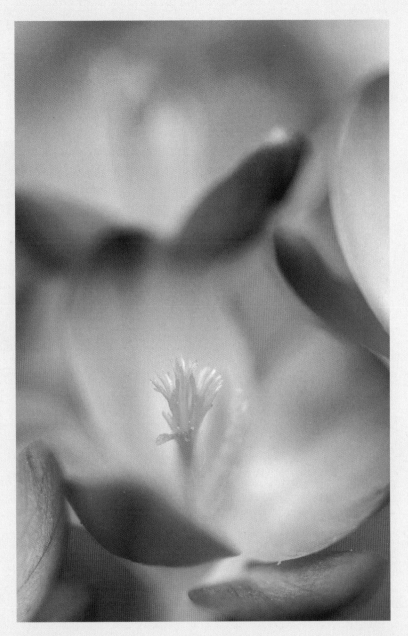

CROCUS

Because yellow and purple are opposite each other on the colour circle, they are complementary colours and so contrast beautifully. I chose a wide aperture and focused on the centre of the front flower so that the petals would become soft suggestions of shape and colour.

Nikon D1x with 105mm macro lens, ISO 125, 1/160sec at f/4.5

CROCUSES AND SNOWDROPS

When I came across a planting of mixed snowdrops and crocuses, I decided to try to include both flowers in a photograph. There were lots of stalks and leaves which looked untidy and distracting, so I focused on the front crocus and selected a wide aperture to soften the background, allowing the snowdrops to go out of focus. I liked the way the crocus petals grew upwards towards the snowdrop petals which grew downwards.

Nikon D1x with 105mm macro lens, ISO 125, 1/200sec at f/3.3

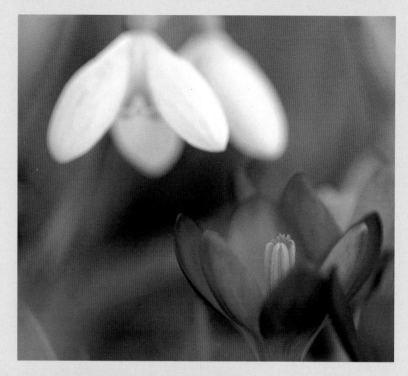

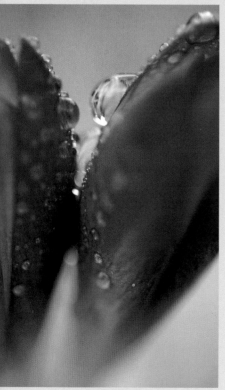

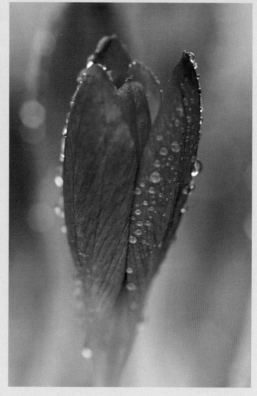

CROCUS WITH WATER DROPS

When I arrived at this bed of purple crocuses it had been raining very gently, hardly any more than a mist in the air, and the result was that each flower was beaded with water droplets. I probably spent a couple of hours here, looking through the viewfinder as I moved around looking for compositions, using a wide aperture for selective focus. I didn't notice how stiff I was becoming lying on the cold ground until I got up afterwards!

FAR LEFT **Nikon D1x with 105mm macro lens, ISO 125, 1/80sec at f/4.8** LEFT **1/60sec at f/5**

CROCUS WITH RAINDROPS

Although crocuses are at their most spectacular when they are open, I also like photographing them when they're closed. This one had rather unusual and lovely blue markings on its petals, which were enhanced by tiny water droplets. By lying flat on the ground, I was able to make sure the frame included only blue and green tones, and a wide aperture differentiated my subject flower from the others behind it.

Nikon D1x with 105mm macro lens, ISO 125, 1/90sec at f/4.2

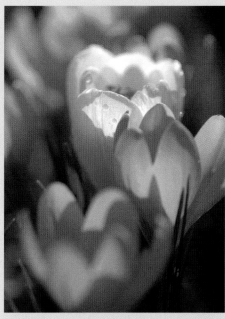

WHITE AND YELLOW CROCUSES

I prefer to photograph crocuses in bright overcast light, but on this particular day there was a clear blue sky, so I made the most of it by positioning myself so that the crocuses were backlit.

Nikon D1x with 105mm macro lens, ISO 125, 1/2500sec at f/3.5

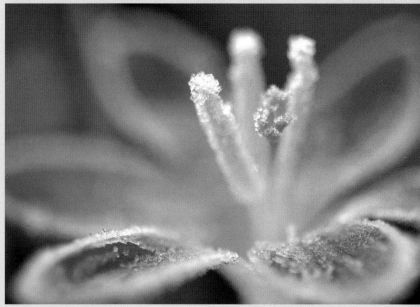

CROCUS WITH FROST

After a couple of nights of hard frost, many of the crocuses in this garden had drooped, so I was delighted to find this one flower with its petals wide open and jewelled with ice crystals. Minutes after I took the photograph the sun had moved onto the flower and melted the frost and the picture had gone.

Nikon D2x with 105mm macro lens, ISO 100, 1/100sec at f/4.2

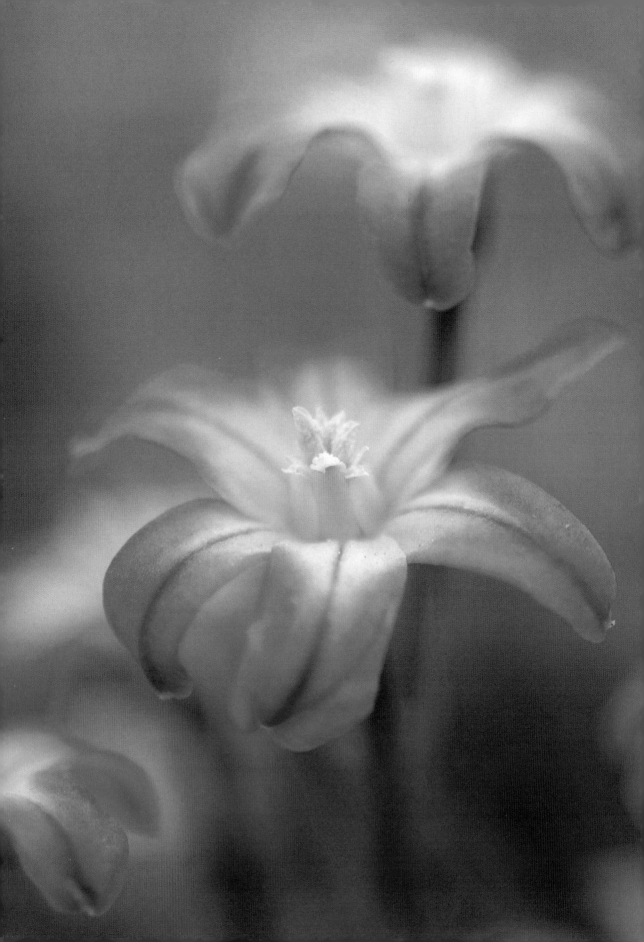

10 Digital Image Processing

Enhancing a good image

When digital photography first appeared on the scene, there was a certain amount of heated debate about whether or not the post-camera processing constituted 'cheating'. I don't think that this is necessarily the case. There are two stages to making a good digital image – capturing the best possible photograph in your camera, and processing it afterwards in such a way as to make the most of the image. You are only cheating if you manipulate an image with the intention to deceive your viewer in some way.

The subject of computer processing of images is a vast one, and many weighty books have been written about it. My aim in this section is just to look briefly at some of the most useful of the tools that are available. Although computer programs can do many things to your image, they are not an alternative to good photography and it is always best to aim to get the best possible photograph at the time of taking it. Then the computer tools can be used simply to enhance an already good image.

Programs such as Photoshop offer the opportunity to add extra effects to photos such as borders and textures.

DAHLIA ON WHITE OPPOSITE

DRIED FLOWERS BELOW

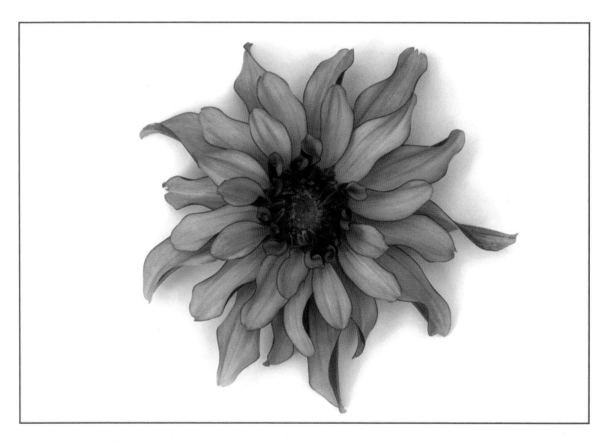

Transferring images

Getting the photographs from your camera onto your computer will usually be done via the software that came with your camera. Once the photographs are displayed on the computer, the first thing to do is to edit them, deleting any that are obviously out of focus or wrongly exposed. Image files take up a lot of space on your computer's hard drive, especially if they are large files such as Tiffs or Raw files, and there is no point in storing a lot of images that you will never use.

Processing of the remaining images can then be done using either your camera's software, or another image editing program. The most widely used of these is Adobe Photoshop, either the full version, which is very expensive, or the Elements version, which is approximately one-tenth of the price of the full version and contains all the tools that most photographers will ever need. In the examples here I have used Elements 6, but the various editing tools will be similar in other versions of Photoshop and Photoshop Elements.

Adjusting brightness and contrast

As a general rule a good digital image should have a full range of tones from white through to black. If it does not, the tonal range can be adjusted using various methods, but my preferred way is to use Levels. Go into the Levels dialogue box (enhance>adjust lighting>levels). A histogram (a bar graph looking rather like a black mountain) will appear, and underneath the histogram are three triangular sliders, black on the left edge, grey in the middle and white at the right. If the edges of the black mountain do not reach as far as the black or white arrows, then adjustments can be made to create more contrast in the image. To do this, make sure the preview box is checked and then slide each pointer in until it reaches the edge of the black histogram. The effect of this can be viewed as you do it, and you can go back a little if you think there is now too much contrast. When you are happy, click on OK.

LEVELS ADJUSTMENTS

Histogram

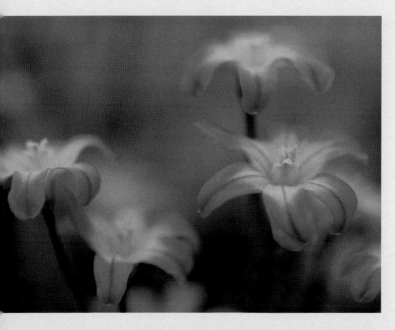

If the black mountain of the histogram already reaches both edges of the graph, then the full range of tones is present in the image, and if any tweaking is necessary, it can be done by sliding the grey arrow to left or right to lighten or darken the mid-tones.

DWARF SNOW GLORY

Version one LEFT – Before levels adjustments
Nikon D1x with 105mm macro lens, ISO 125, 1/320sec at f/4

Version two BELOW – After levels adjustments

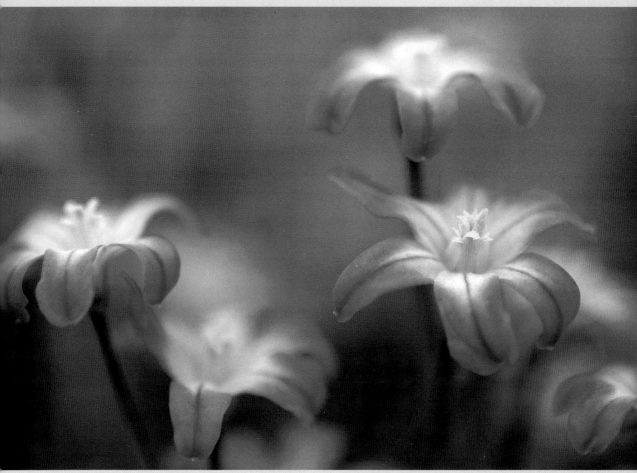

TREE WITH SUNFLOWERS

Version one RIGHT – Before increasing
colour saturation

**Nikon D1x with 80-400mm lens at
400mm, ISO 125, 1/160sec at f/10**

Version two BELOW – After increasing
colour saturation

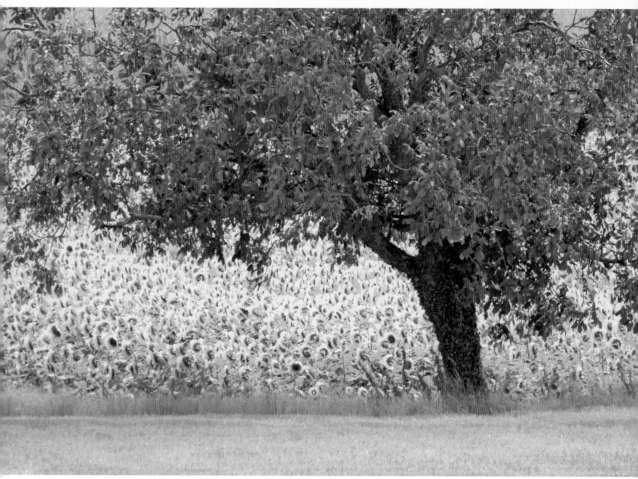

Increasing colour saturation

If your photograph looks a little flat or insipid, it is very easy to increase the colour saturation in Photoshop. However don't be tempted to over-saturate or the result will look artificial. A small tweak is usually all that is necessary. To adjust the saturation, click on enhance>adjust colour>adjust hue/saturation. A dialogue box will appear with three sliders, and it is the middle one that affects saturation. Sliding it to the right will increase the colour saturation, while sliding it to the left will desaturate the colours. Make sure the preview box is ticked, and then you will be able to see the effect as you move the slider. If you want to make more precise changes by increasing the saturation of a specific colour, you can click on the drop down menu by Edit and select which colour you want your changes to affect. When you are happy, click OK.

COLOUR SATURATION

adjustment slider

preview checked

Adjusting colour temperature

As I mentioned in Chapter Six, different types of light have different colour temperatures, which can sometimes result in your photograph having an unwanted colour cast. This can usually be avoided by setting the appropriate white balance on the camera at the time of taking the picture, but if this was not done, the colour cast can be removed in Photoshop. Again, there are various ways of doing this, but one of the easiest is via the Colour Variations box. To use this, click on enhance>adjust colour>colour variations. A dialogue box will appear with six thumbnails showing the effect of increasing or decreasing red, green or blue in your image, as well as the effects of lightening or darkening it. The amount of the increase or decrease can be adjusted by moving the slider on the left. Once you click on one of the thumbnails, the effect will be shown in the After box at the top. If you don't like it, you can click Reset Image and try again. When you're happy, click on OK.

COLOUR VARIATIONS

Thumbnails

DAPHNE
This photograph of daphne was taken in the shade on a clear day, but the camera's white balance was left on auto, which resulted in a very blue cast. I selected Decrease Blue in Colour Variations to restore the natural colours.
Nikon D1x with 105mm macro lens, ISO 125, 1/60sec at f/4.5

Version one LEFT – Before adjusting colour temperature

Version two BELOW – After adjusting colour temperature

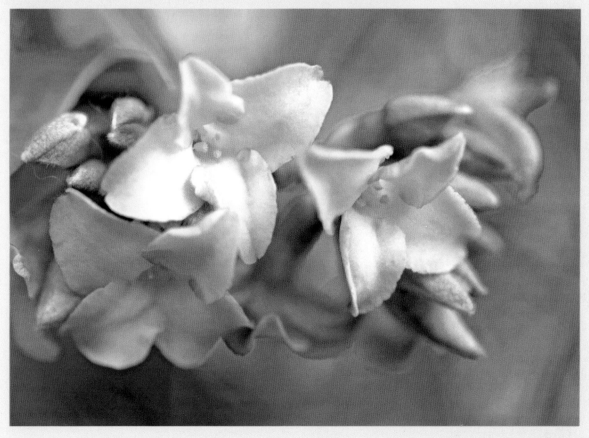

PINK MAGNOLIAS

I felt that this picture of magnolias had too much space to the right of the flowers, and also there was a distracting light coloured leaf at the very right of the frame. This was easily corrected using the cropping tool.

Nikon D1x with 80-400mm lens at 300mm, ISO 125, 1/250sec at f/5.3

Version one RIGHT – Before cropping

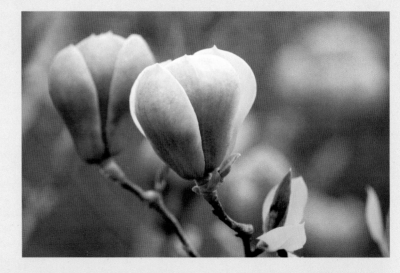

Version two BELOW – After cropping

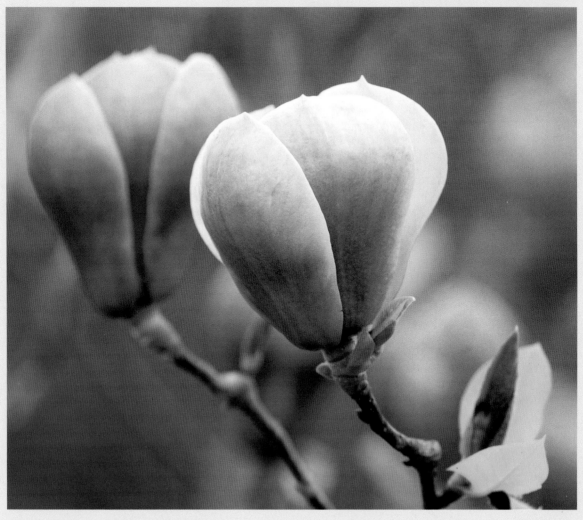

Cropping

There will be times when a photograph can be improved by cropping, either to strengthen the composition, or to remove an unwanted element at the edge of the frame. To crop a picture, select the crop tool from the tool menu, then click on the image and drag the tool to select the area you want to keep. The part of the image which will be cropped off is now shaded. You can make fine adjustments to this by dragging the little squares on the outline of the cropped area. When you're happy with your crop, press Enter.

CROPPING

shaded area to be cropped off

Cleaning

Alt-click the area you want to clone from

Tiny particles of dust and dirt inside your camera may appear as dark specks in your image. These can be removed in Photoshop using either the Clone tool or the Healing Brush tool. These both replace the blemish with a sample taken from another part of the image, but while the Clone tool simply replaces, the Healing Brush tool also blends the sample into the background. To check for dust spots in your image, click on the magnifying tool and zoom in to 100 per cent.

Dust spots are particularly obvious in plain areas of an image, such as the blue sky in this sunflower photograph. To remove them, zoom into the image, then click on the Clone or Healing Brush tool. There is a choice of brush types and sizes in the drop-down menus at the top, and the best thing is to experiment to see how they work. For this image, I used the Healing Brush set at 50 pixels. For more detailed work I would choose a smaller brush size. Next you need to choose the area that you will clone from – it should be as similar as possible to the part you want to replace. Hover your cursor over your chosen area, then press the Alt key and click your mouse at the same time. Then reposition the cursor over the dust speck and click the mouse again. The dust speck will be replaced with the area you Alt-clicked.

Position cursor over dust speck and click

The dust speck is now removed

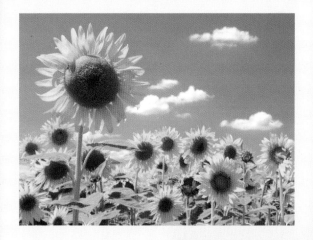

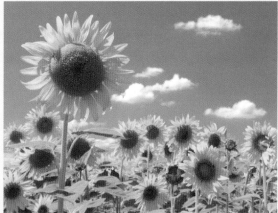

SUNFLOWERS AND CLOUDS
Original image with dust marks [LEFT] and retouched image [RIGHT]
Nikon D1x with 28-105mm lens at 48mm, ISO 125, 1/30sec at f/18

Blemish to retouch

The same technique can also be applied to removing other blemishes, such as a brown spot on a petal, from your photographs. It is a matter of personal choice how far you go with this, and there are people who disapprove of doing anything beyond dust removal. I would always prefer to take a photograph of a completely unblemished flower than photograph a damaged one and tidy it up in Photoshop, but there will be occasions where this is not possible, and I do not see a problem with using the clone tool to remove small blemishes.

WATER LILY BUD
The light on this water lily bud was beautiful, but there was a small brown blemish on the emerging pink petal. This was easily removed in Photoshop using the clone tool.
Nikon D1x with 80-400mm lens at 400mm, ISO 125, 1/320sec at f/5.6

Before

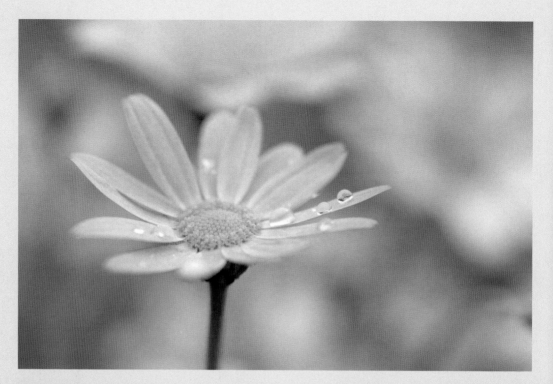

After

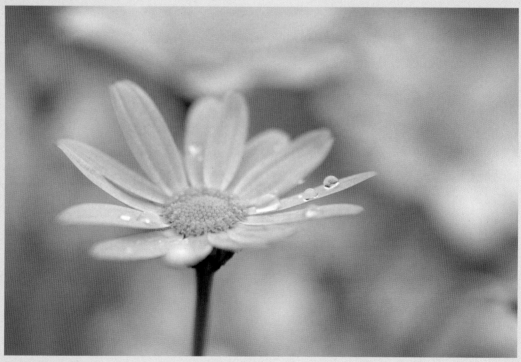

ARGYRANTHEMUM

Nikon D1x with 105mm macro lens, ISO 125, 1/1500sec at f/5

Sharpening

Sharpening should be done last, after you have made any other adjustments you want to make to your photograph. Digital images are slightly soft when they are captured because of the way the sensor processes information, and most file types are then sharpened in-camera. Raw files however are not, so they will need to be sharpened in Photoshop. Sharpening can make your image appear sharper by increasing the edge contrast, but it cannot make out of focus areas sharp. There are various methods of sharpening in Photoshop, but probably the most widely used is the oddly named Unsharp Mask. To sharpen an image, click on enhance>unsharp mask. A dialogue box with three sliders will appear, and these can be used to adjust the sharpness of the image. As with other Photoshop tools, experimenting is the best way to learn how to use the unsharp mask. Do beware of over-sharpening an image, as this can give the appearance of halos around the sharpened edges and the result will look unnatural.

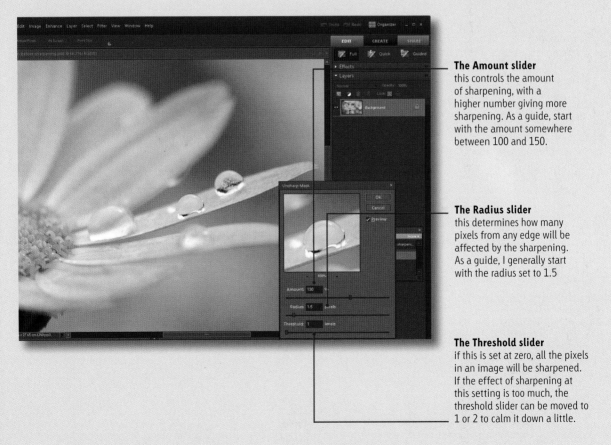

The Amount slider
this controls the amount of sharpening, with a higher number giving more sharpening. As a guide, start with the amount somewhere between 100 and 150.

The Radius slider
this determines how many pixels from any edge will be affected by the sharpening. As a guide, I generally start with the radius set to 1.5

The Threshold slider
if this is set at zero, all the pixels in an image will be sharpened. If the effect of sharpening at this setting is too much, the threshold slider can be moved to 1 or 2 to calm it down a little.

CACTUS

I was attracted to this flowering cactus because of the way the flowers grew in a ring around the top of it, their pink petals beautifully offset by the green of the cactus and the white of the spines. When I looked closely I found that the circle of flowers was in fact incomplete, so I decided to photograph just the best part of it. I liked the way the spines within the circle of flowers formed a heart shaped pattern, and I framed the picture so the heart would be included. Because I was photographing so close up to the cactus, I had to use a very small aperture to get as much sharpness as possible throughout.

Nikon D1x with 105mm macro lens, ISO 125, 1/6sec at f/38

It is always a good learning experience to set yourself a theme and to take photographs to illustrate that theme over a set period of time. You could focus on a particular species of flower or you could concentrate on a particular colour or even shape. One theme that can be fun to try is to find natural abstracts and patterns. Once you start to look out for them, you will notice them everywhere!

When I'm photographing flowers I'm always aware of other parts of plants such as bark, leaves and so on, and these can be a particularly good source of pattern pictures. As well as this, groups of similar flowers together can make a pattern just by virtue of the repetition of their shapes. Abstract images can also be found within a flower, by cropping in and selecting just a part of the whole.

When you find a plant with the potential for an abstract image, the key to making a good photograph of it is in the framing. Using the right lens and the right viewpoint can emphasize a pattern, as can cropping in tight on it to exclude irrelevant detail. For instance, if you notice a tree with a lovely pattern on the bark, but you stand fairly well back from it and use a standard lens, so that the photograph also includes branches, leaves and the area behind

the trunk, the likelihood is that the bark pattern will not be very obvious in the resulting image. If, however, you switch to a macro lens and go in close to the tree trunk so that you fill the frame with it, you will have a much more abstract image which will be all about the pattern. There is no single 'right light' for this type of photograph, but very often a bright overcast light will turn out to be the best, as contrast and shadows caused by direct sunlight can detract from the pattern on a plant – unless of course the shadows themselves are creating the pattern!

BLUE BIRCH LEFT **AND BETULA HERGEST** BELOW
Tree bark can be a wonderful source of patterns. For both these photographs I used my macro lens and had my camera on a tripod so that I could really take care in fine-tuning my exact composition. The unusual colours of the bark combined with the shapes and patterns provided at least an hour of happy photography in each case!
LEFT **Nikon D1x with 105mm macro lens, ISO 125, 1/2.5sec at f/32**
BELOW **Nikon D2x with 105mm macro lens, ISO 100, 1sec at f/40**

ABSTRACT FLOWER

This stunning flower had different shades of red and pink in its petals, and the edges of the petals caught the light in a way that made them look almost golden. In sharp focus the picture didn't work, but when I defocused, all the gorgeous colours were emphasized, and the image became a completely abstract pattern of colour and shape.

Nikon D1x with 105mm macro lens, ISO 125, 1/250sec at f/4.5

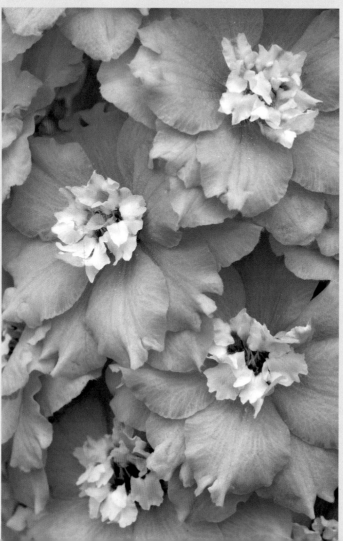

DELPHINIUM

I cropped in close on this delphinium to make a pattern picture using just some of the flowers. The orderly repetition of the shapes and colours of the petals produces a restful image, an effect which is enhanced by the gentle colours from the cool part of the colour circle.

Nikon D1x with 105mm macro lens, ISO 125, 1/125sec at f/16

CALLA LILY

The aspect of this calla lily that attracted me was the beautiful curve of the petal edges. A photograph of the complete flower inevitably involved quite a lot of background because the flower was so tall and thin, and the impact of the curves would have been lost, so I decided to go in close and make an abstract picture which emphasized these lovely, sinuous shapes.

Nikon D2x with 105mm macro lens, ISO 100, 7.1sec at f/36

PINK GERBERA

Flower centres can be good sources of abstract pictures, and this pink gerbera was no exception. I used a small aperture to make sure that all the various parts of the flower were sharp.

Nikon D2x with 105mm macro lens, ISO 100, 3sec at f/36, exp comp -0.7

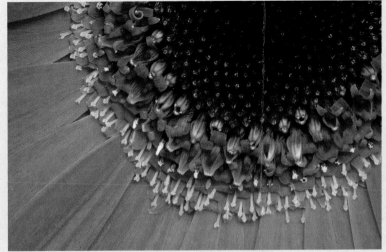

Index

Captions to illustrations are indicated by page numbers in **bold**.

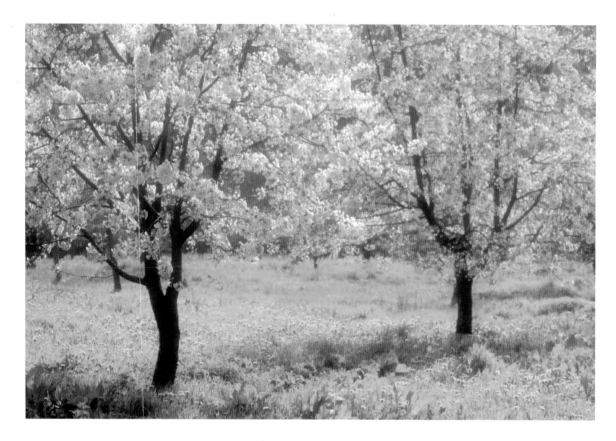

A full list of titles published by the Photographers' Institute Press
is available by visiting our website: www.pipress.com

All titles are available direct from the publishers or
through bookshops and specialist retailers.
To place an order, or to obtain a complete catalogue, contact:

Photographers' Institute Press
166 High Street, Lewes,
East Sussex BN7 1XU, United Kingdom
Tel: (01273) 488005
Fax: (01273) 402866
Email: pubs@thegmcgroup.com
Website: www.pipress.com
Orders by credit card are accepted